Remembering
Colorado Springs

Sharon Swint

TURNER
PUBLISHING COMPANY

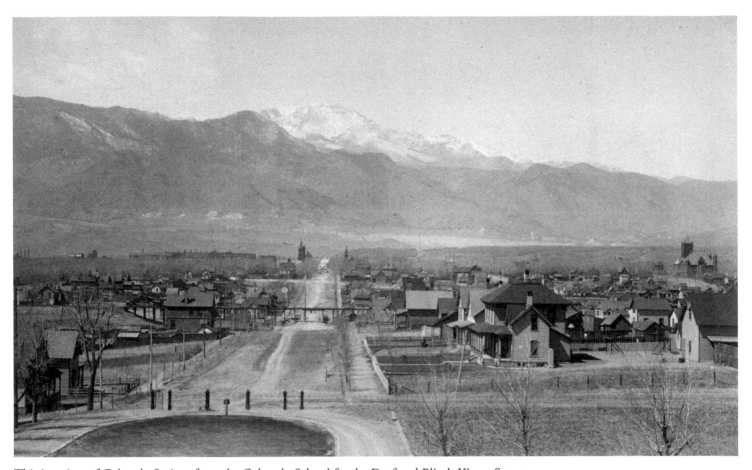

This is a view of Colorado Springs from the Colorado School for the Deaf and Blind. Kiowa Street ambles toward the Rocky Mountains to the west. The yard, circle drive, and fence in the foreground are part of the school. Various landmarks are visible—the Atchison, Topeka, & Santa Fe Railroad trestle; the mansion of Count Pourtales at the end of the street; and Colorado Springs High School to the north. The School for the Deaf and Blind was established in 1874 by the territorial legislature.

Remembering
Colorado Springs

Turner Publishing Company
www.turnerpublishing.com

Remembering Colorado Springs

Copyright © 2010 Turner Publishing Company

Library of Congress Control Number: 2010932279

ISBN: 978-1-59652-706-5

Printed in the United States of America

ISBN: 978-1-68336-820-5 (pbk.)

CONTENTS

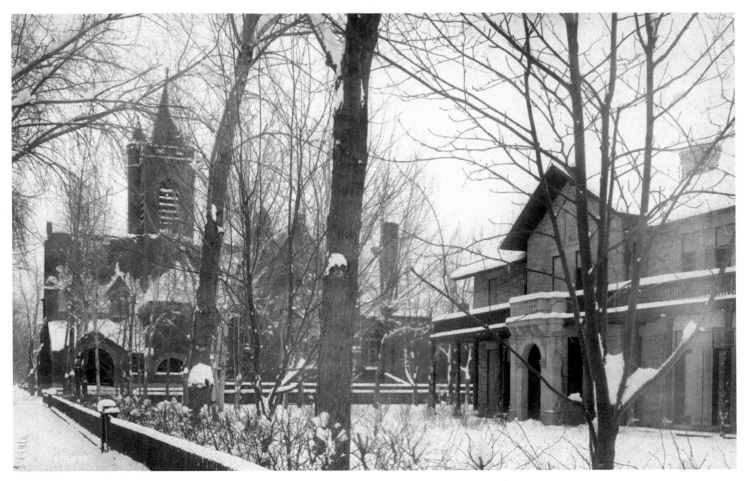

The stone residence of pioneer Irving Howbert is shown on the right on South Weber Street. The First Baptist Church is farther down the block at Kiowa and Weber. Howbert arrived in the Pikes Peak region in 1860 with his Methodist minister father. He was the El Paso County Clerk in 1869 when General Palmer began to acquire land for the town, later becoming president of the First National Bank.

ACKNOWLEDGMENTS

This volume, *Remembering Colorado Springs,* is the result of the cooperation and efforts of many individuals and organizations. It is with great thanks that we acknowledge the valuable contribution of the following for their generous support:

Denver Public Library

Library of Congress

Old Colorado City Historical Society

Pikes Peak Library District

Tutt Library, Colorado College

This book is dedicated to the many, many men, women, and children who came to the frontier for a variety of reasons and stayed on to build an amazing town, Colorado Springs. It is also dedicated to the many historians who continue to research and write, and educate others concerning our regional history. There is no substitute for the tenacity of either group.

PREFACE

Colorado Springs has thousands of historic photographs that reside in archives, both locally and nationally. This book began with the observation that, while those photographs are of great interest to many, they are not easily accessible. During a time when the city is looking ahead and evaluating its future course, many people are asking, How do we treat the past? These decisions affect every aspect of the city—architecture, public spaces, commerce, infrastructure—and these, in turn, affect the way that people live their lives. This book seeks to provide easy access to a valuable, objective look into the history of Colorado Springs.

Although the photographer can make decisions regarding subject matter and how to capture and present it, photographs, unlike words, seldom interpret history subjectively. This lends them an authority that textual histories sometimes fail to achieve, and offers the viewer an original, untainted perspective from which to draw his own conclusions, interpretations, and insights.

This project represents countless hours of review and research. The researchers and writer have reviewed many hundreds of photographs in numerous archives. We greatly appreciate the generous assistance of the organizations listed in the acknowledgments of this work, without whom this project could not have been completed.

The goal in publishing this history is to provide broader access to this set of extraordinary photographs, as well as to inspire, provide perspective, and evoke insight that might assist citizens as they work to plan the city's future. In addition, the book seeks to preserve the past with adequate respect and reverence.

With the exception of touching up imperfections that have accrued with the passage of time and cropping where necessary, no changes have been made. The focus and clarity of many images is limited by the technology and the ability of the photographer at the time they were taken.

The work is divided into eras. Beginning with some of the earliest known photographs of Colorado Springs, the first section records photographs through the end of the nineteenth century. The second section spans the beginning of the twentieth century through the World War I era. Section Three moves from the 1920s to the eve of World War II, and the last section covers the World War II era to recent times.

In each of these sections we have made an effort to capture various aspects of life through our selection of photographs. People, commerce, transportation, infrastructure, religious institutions, and educational institutions have been included to provide the most widely encompassing look at the subject feasible.

We encourage readers to reflect as they go walking in Colorado Springs, exploring the city, its parks, and its neighborhoods. It is the publisher's hope that in utilizing this work, longtime residents will learn something new and that new residents will gain a perspective on where Colorado Springs has been, so that each can contribute to its future.

—*Todd Bottorff, Publisher*

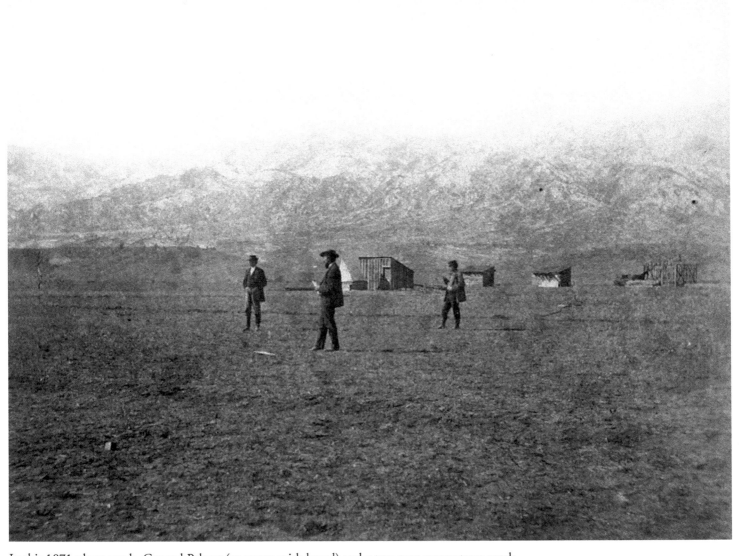

In this 1871 photograph, General Palmer (at center, with beard) and a two-man survey team work near the area of Pikes Peak Avenue and Tejon Street laying out the town of Colorado Springs. The first stake of the town was driven in this vicinity, noticeably surrounded by a vast open prairie. Plow rows were used to mark streets.

The Early Years

(1870s–1899)

Eight well-dressed men and women and a child pose around the mineral-encrusted basin at Navajo Springs in Manitou. This early photograph from around 1872 shows Navajo Springs without a pavilion, which was added later.

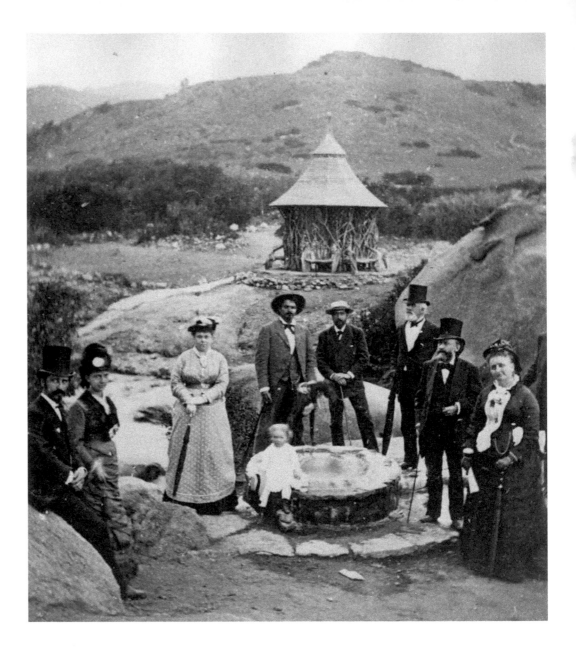

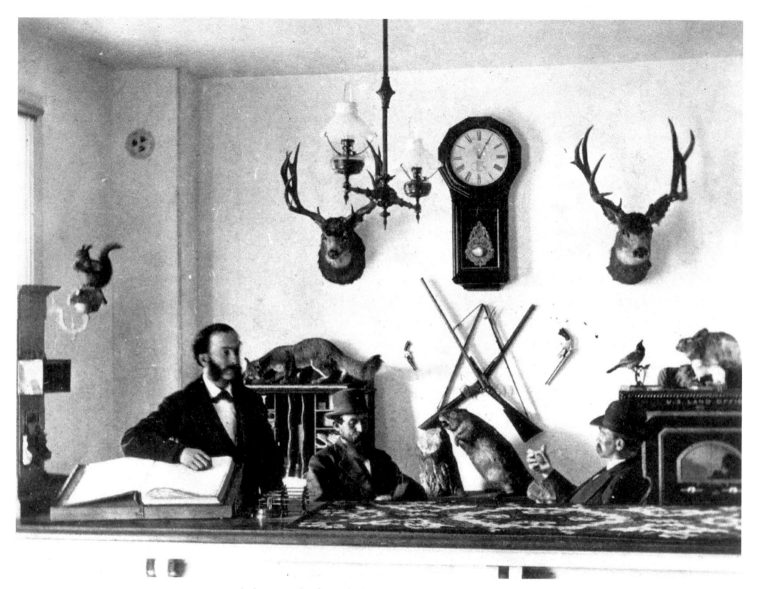

A clerk sits at the front desk of the Manitou House Hotel in Manitou in August 1874. His arm rests on the guestbook on the counter. Stuffed animals, armaments, and a clock combine to form unique interior decor. "Colliers Rocky Mountain Scenery" stated that the hotel was "pleasantly located near the springs and is a central point for tourist . . . appointments," with excellent accommodations and management.

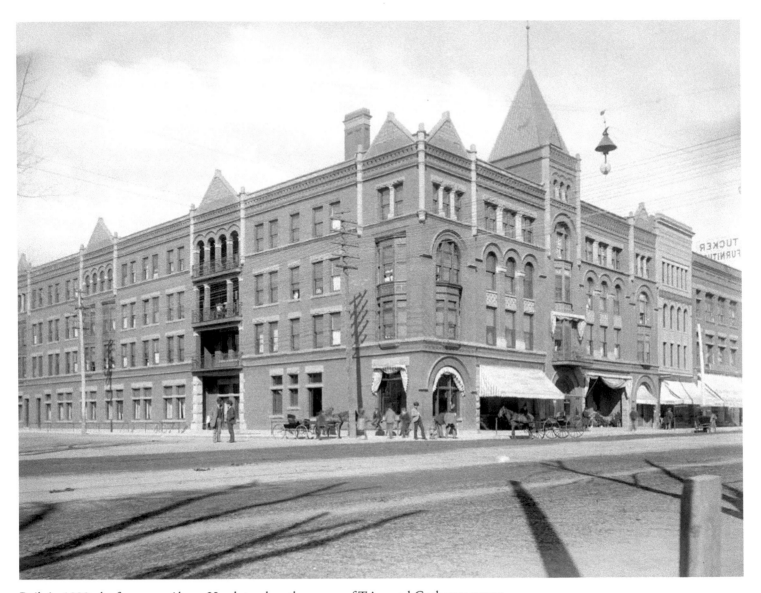

Built in 1889, the four-story Alamo Hotel stood on the corner of Tejon and Cucharras streets. Pedestrians outside seem to be enjoying a fine, wintry afternoon sometime late in the nineteenth century. The handsome brick and stone edifice was a luxury hotel with a spacious lobby, marble columns, and sweeping staircase. It stood the test of time, but did not withstand urban renewal in the 1970s, which destroyed many of the city's most beautiful and historic buildings.

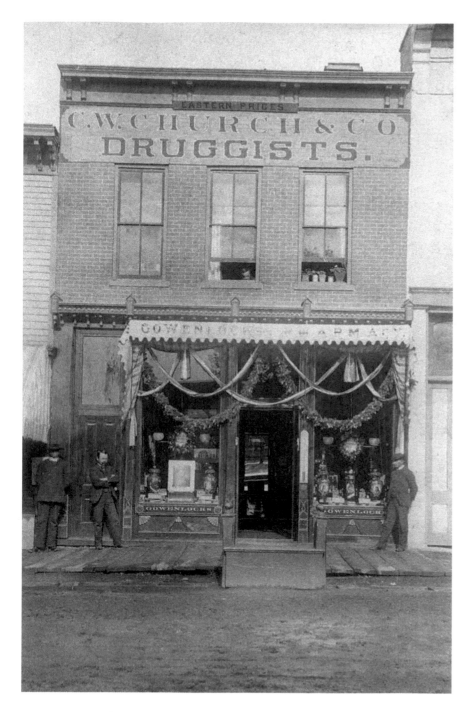

Gowenlock's grocery sent this Christmas and New Year's card to their customers in the holiday season of 1884-85, showing the store festooned with garland. The store was located at 26 South Tejon in the center of Colorado Springs. The second-story sign says, "C. W. Church & Co. Druggists" and "Eastern Prices." The reverse of the card thanked customers for their business.

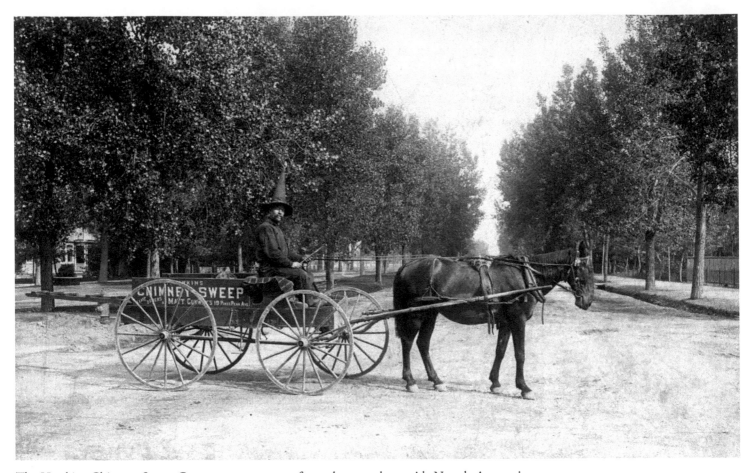

The Hawkins Chimney Sweep Company wagon stops for a photograph on wide Nevada Avenue in the 1890s. Isaac Hawkins, a well-known figure in the area for many years, sports an unusual pointed hat. Hand-lettered advertising on the wagon says, "Hawkins Chimney Sweep, Leave Orders at Matt Conway's 19 Pikes Peak Ave."

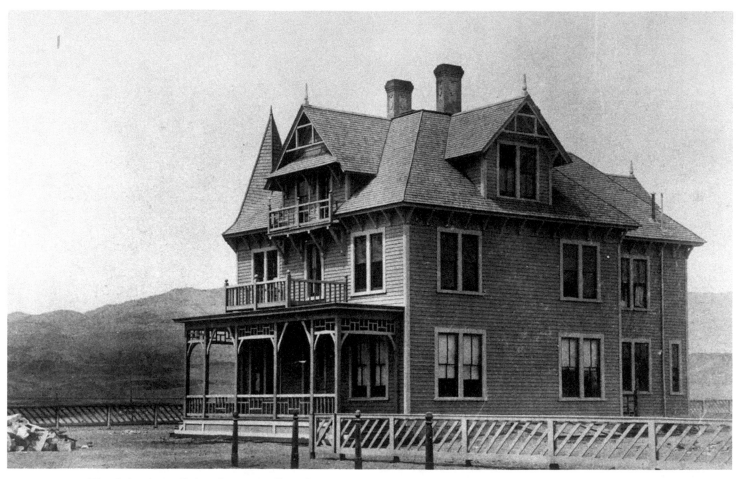

The Columbian Club, a frame spindle-style Victorian building, was a girl's dormitory near the Colorado College campus on the northeast corner of North Cascade Avenue and Columbia Street. On January 1, 1884, it burned to the ground. Soon thereafter College Hose Company #4 formed to help protect the college campus and the north end of town. It was provided with a house for equipment and a hose cart.

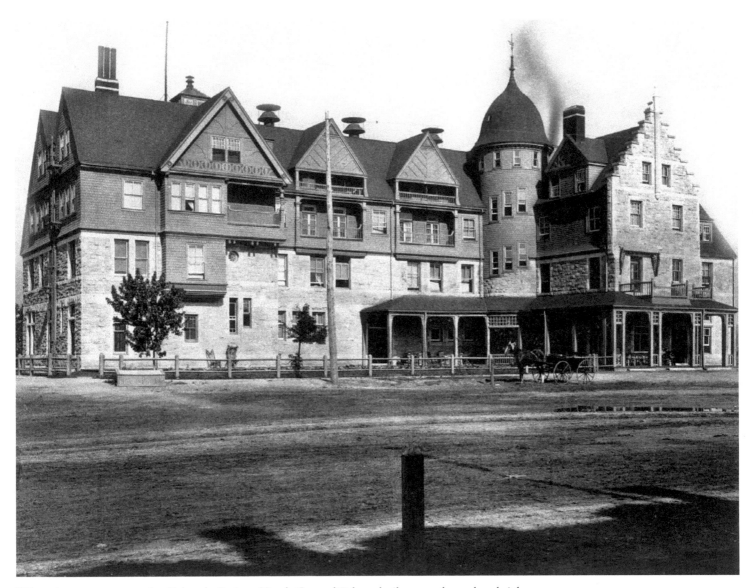

When the town outgrew the Colorado Springs Hotel, General Palmer built a grand new hotel right across the street for $125,000. Since the hotel housed Palmer's large stuffed-animal collection, it was named the Antlers Hotel. Amenities included an elevator, central heat, gaslights, bridal suite with private bath, barbershop, Turkish bath, and two bathrooms on each floor. This image shows the hotel as it appeared around 1883. The first Antlers burned in 1898.

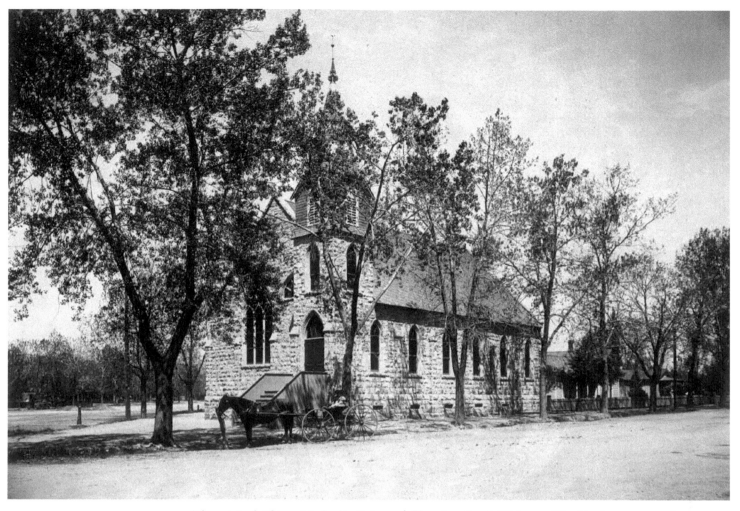

The original African Methodist Episcopal Church at South Weber and Pueblo Avenue was a frame building constructed in 1884 on a lot donated by the Colorado Springs Company (General Palmer's company). The congregation replaced the frame structure with this Gothic Revival stone chapel. Members used their own wagons and horses to bring sandstone from Bear Creek Canyon on the south side of town for construction. When completed, it was renamed Payne Chapel for Daniel Payne, an early bishop. Having outgrown the space, the congregation sold Payne in the 1980s. The A.M.E. Church was an offshoot of American Methodism formed to protest slavery.

Members of the Manitou Springs Fire Department pose in their dress uniforms sometime in the 1880s. The hats and belt buckles are initialed MFD (for Manitou Fire Department). The shirts carry "WB," the initials of Dr. William Bell, founder of Manitou.

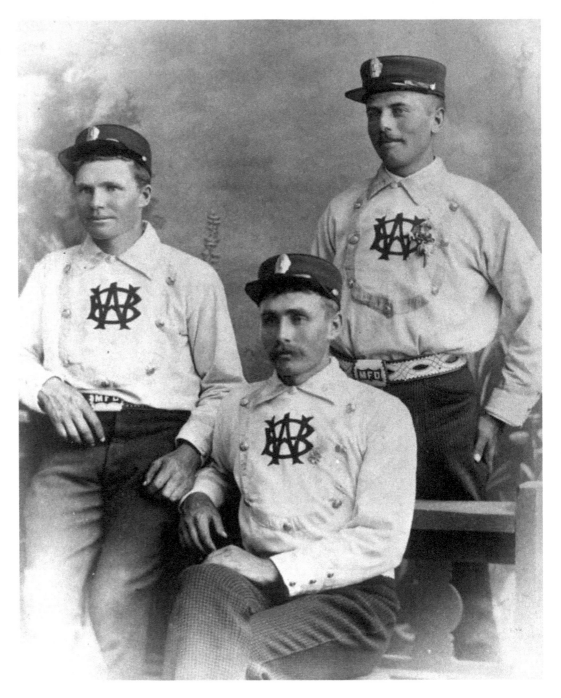

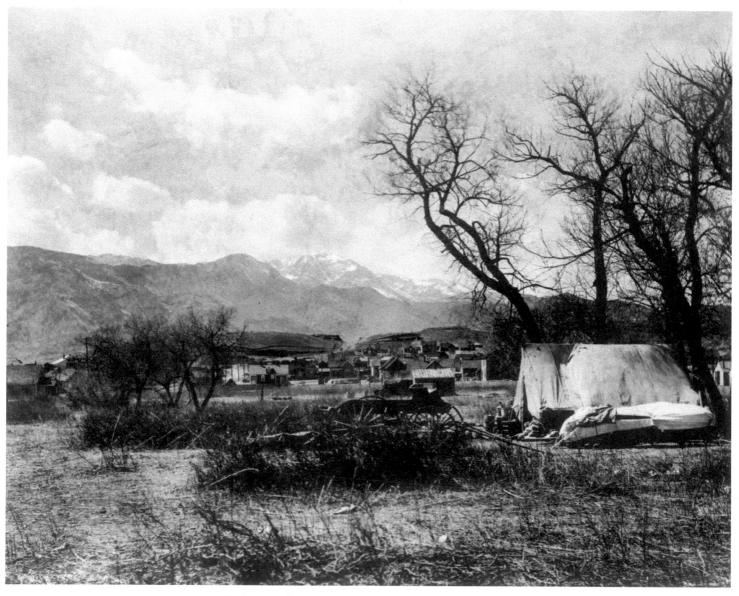

Settlers—in houses and in tents—on the eastern side of the Rockies enjoyed a magnificent view of Pikes Peak. Benefiting from good advertising, Colorado Springs grew so quickly that newcomers could find themselves relying on tents for shelter.

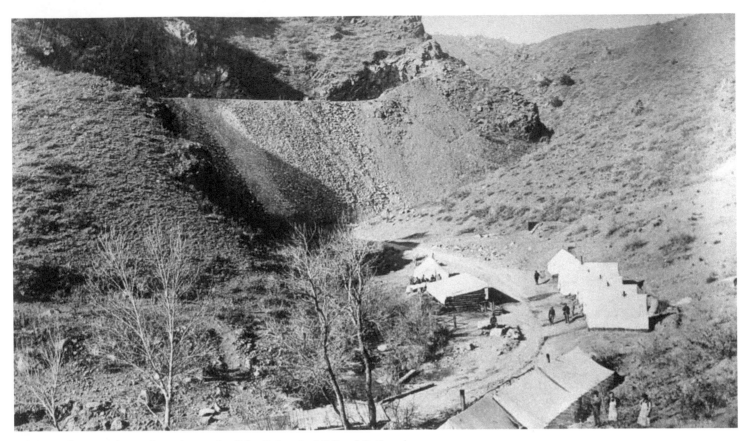

While working on the tracks and tunnels of the Colorado Midland Railroad, contractors set up a line of tents and a log cabin with a canvas roof about 1886. In view is the site of the no. 7 and no. 8 tunnels going west.

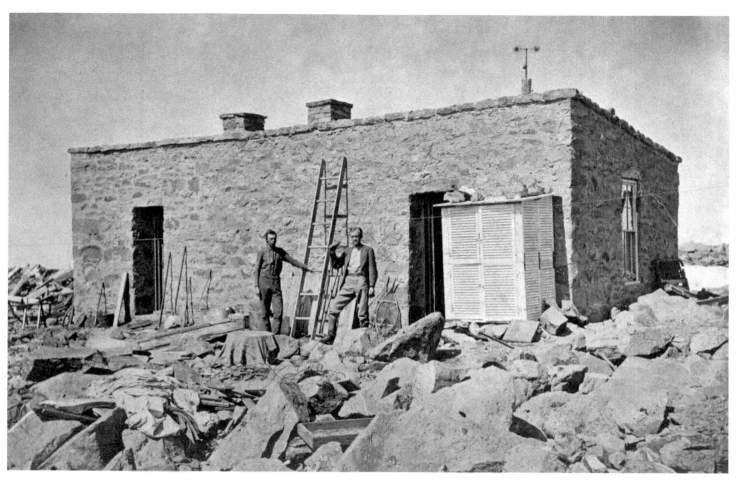

This photograph shows Albert James Myer, holding binoculars, and another man standing outside a stone weather observation station on Pikes Peak. An early telegraph line wound through trees, boulders, and bushes to send weather reports back to the public. At 14,110 feet, the two-room weather station atop Pikes Peak was the highest in the world around 1873. Young men trained by the Signal Corps took turns living year-round on the isolated mountain, where they endured many hardships including loneliness, primitive living conditions, and poor health.

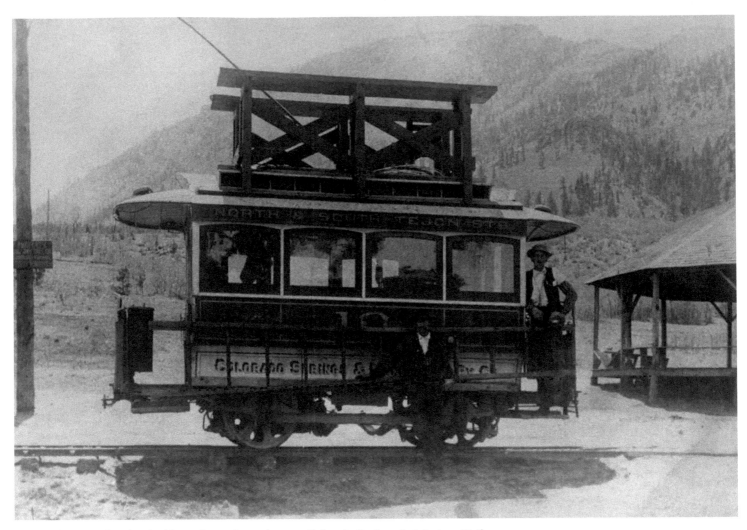

Preceded by a trolley that had been drawn by 10 horses, Colorado Springs & Manitou Railway Company streetcar No. 10 sits on the tracks with the mountains in the background. The streetcar ran up and down Tejon Street north and south from Costilla Street to the Colorado College campus. A second line was built to Colorado City in 1888. Winfield Scott Stratton later bought the line and renamed it Colorado Springs and Interurban Railway, investing approximately $2 million before his death to upgrade the tracks, expand the routes, and replace the cars in an effort to make it the best trolley system in the U.S. The trolley line hauled coal at night and ran a sprinkler car to keep the dust down.

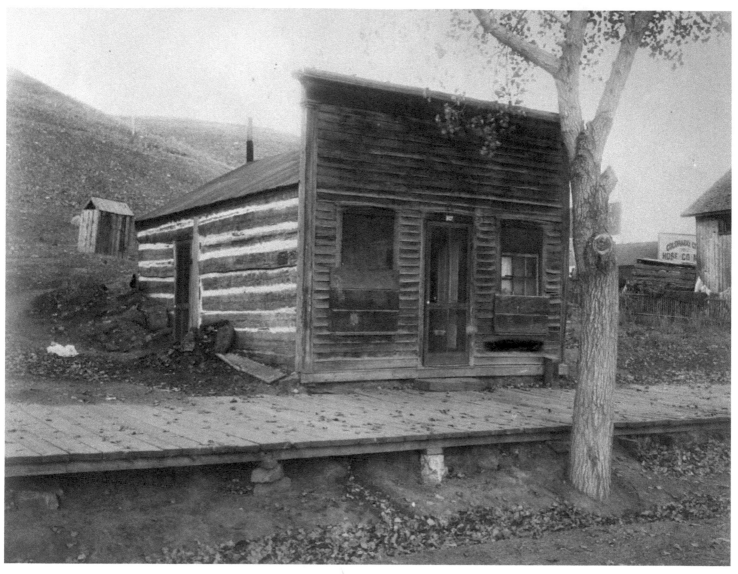

This 1858 cabin was used as an office by Dr. J. P. Garvin in Colorado City. It was owned by M. E. Beach, a member of the Colorado legislature. Later it was used as a Chinese laundry, the office of the first Clerk of the County, and an attraction on the Broadmoor Golf Course. The restored cabin is now located in Bancroft Park on West Colorado Avenue. Early Colorado City promoters referred to it as the Old Capitol Building, a misnomer.

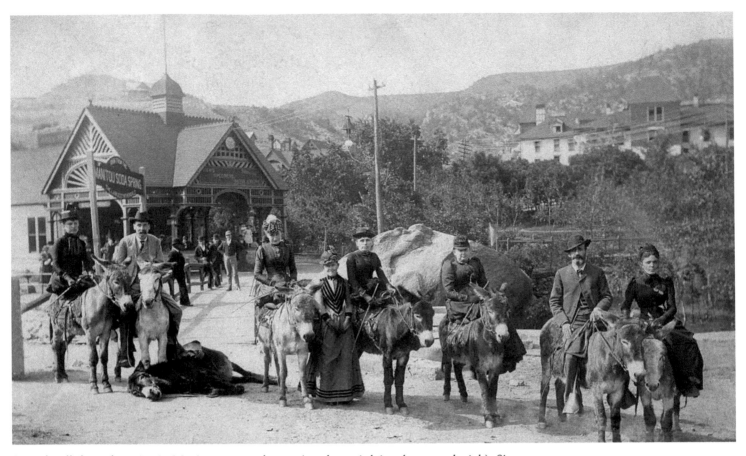

Several well-dressed tourists in Manitou pose on burros (one burro is lying down on the job). Signs at the Manitou Soda Springs pavilion read, "Manitou Soda Spring, the Largest in the World" and "Views Specimens Native Jewelry A. H. Davis."

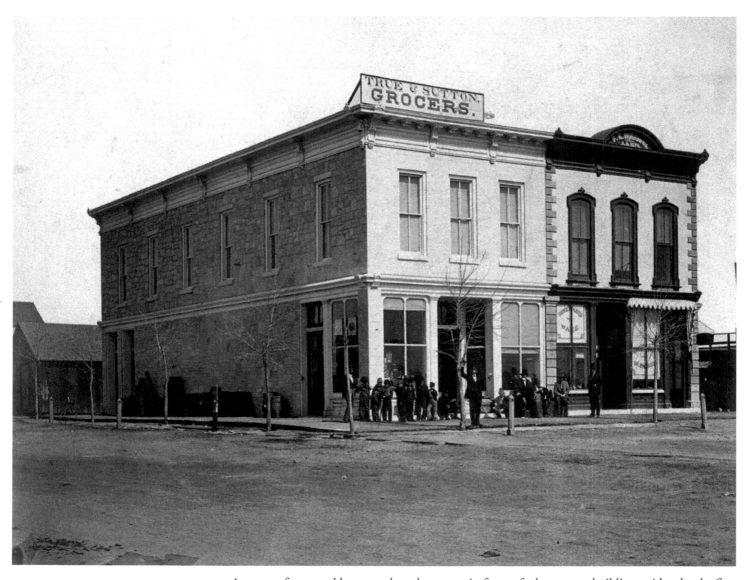

A group of men and boys stand on the corner in front of a large stone building, said to be the first grocery in Colorado Springs. Signage on the building at left says, "True & Sutton, Grocers," on the building at right, "F. E. Huggins, AD 1874."

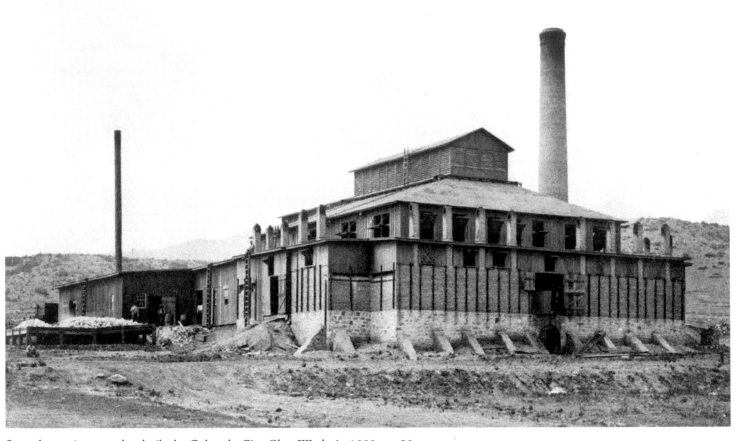

Several prominent settlers built the Colorado City Glass Works in 1889, on 20 acres near present-day Wheeler Street in Colorado City. The Manitou Mineral Water Bottling Company used the Glass Works bottles for their products.

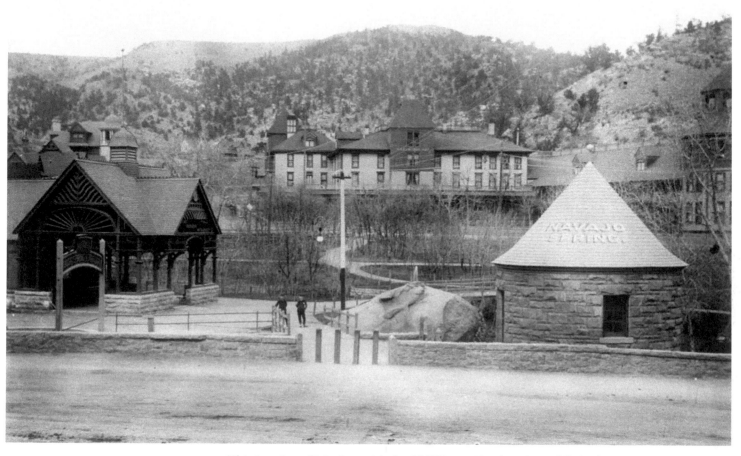

This is a view of Manitou with the Cliff House Hotel in the middle background. The small stone building to the right is labeled Navajo Spring, and the building to the left is the Manitou Soda Spring pavilion. Above the soda springs is Windemere, the home of Aspen mine owner and financier Jerome Wheeler. In recent years, the Cliff House has been renovated and restored to its 1890s elegance.

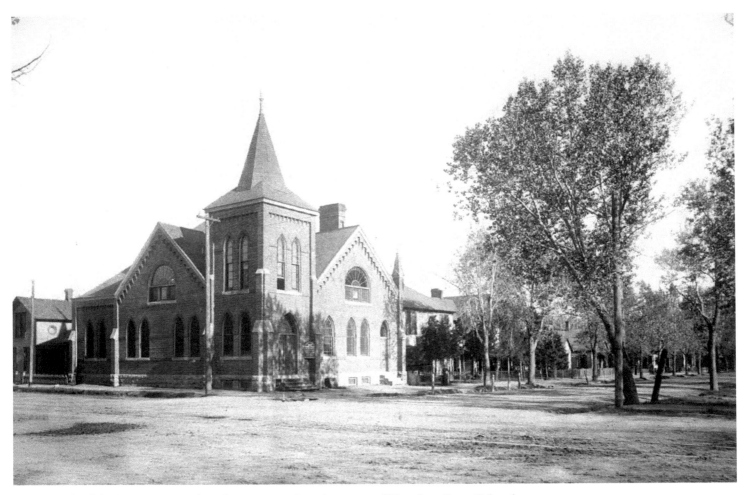

The Church of the Strangers United Presbyterian stood on the corner of Huerfano (later Colorado Avenue) and Nevada. It was a corbelled brick building with a corner entry and steeple. The church was organized in the summer of 1888 and occupied in February 1890. Today, this downtown corner is occupied by businesses.

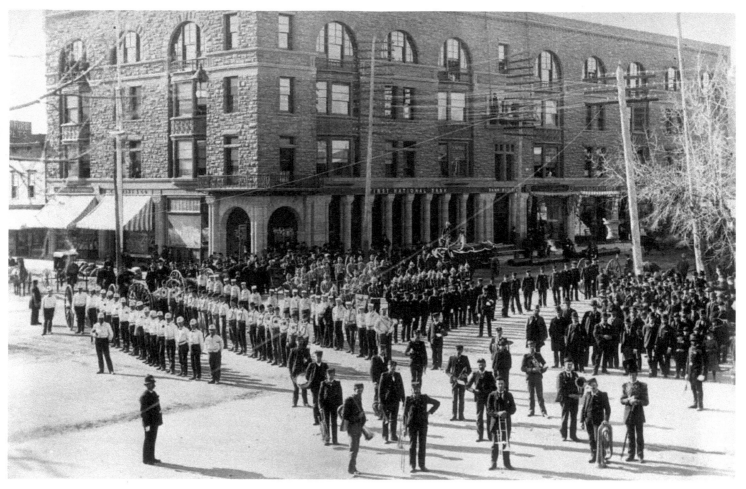

The Colorado Fire Department poses for a group shot at "Busy Corner" (Cascade Avenue and Tejon Street) in front of the First National Bank building sometime in the 1890s. Fire fighters were participating in a parade in full uniform with helmets, conductor's caps, and double-breasted jackets. Some of the members were part of the fire department band, which poses at front holding various instruments. The band member at lower right sports a busby.

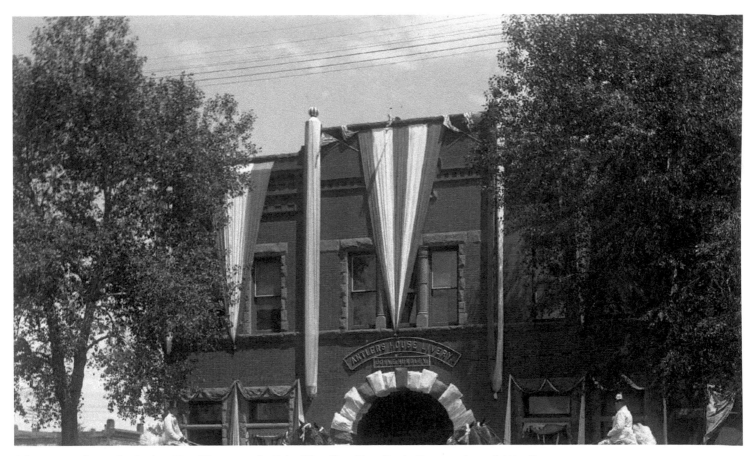

This image shows the Antlers Hotel livery run by John Hundley. Hundley built a rough road 17 miles up Pikes Peak. The road was the predecessor to the Pikes Peak Highway. Each morning at ten past eight, Hundley parked mule-drawn surreys at the Midland Train Station in Cascade offering a trip up Pikes Peak and return before dark. The cost was $2.50 per person.

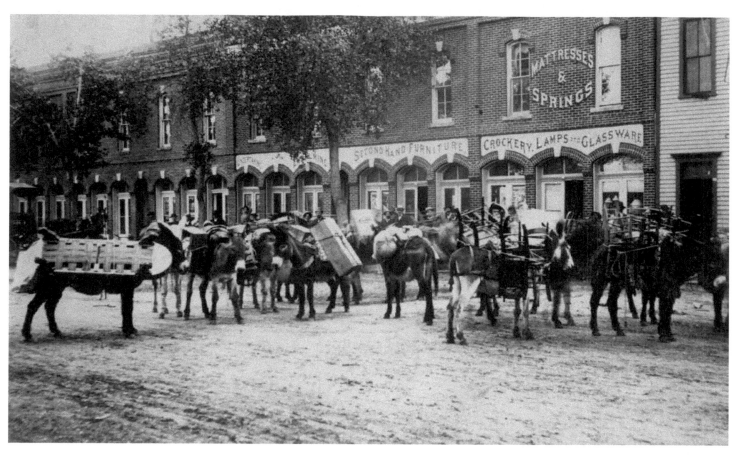

Burros loaded with chairs and assorted furniture bound for the Halfway House Hotel up Pikes Peak stand in the street in front of Fairley Brothers Furniture and Undertaking. Building signage says, "Undertaking, Embalming, Secondhand Furniture, Crockery, Lamps, and Glassware" and "Mattresses and Springs." The climb was arduous. Beginning at the city's elevation of 6,035 feet, the trek would stop short of the mountain's summit, at 14,110 feet.

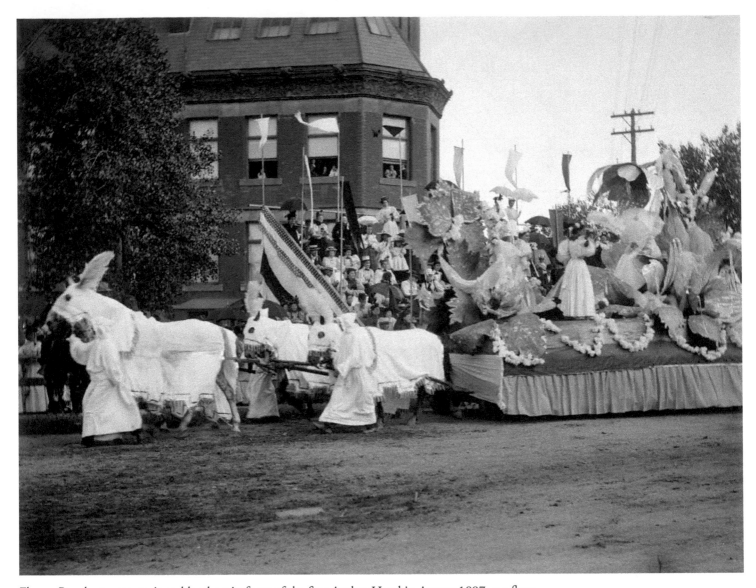

Flower Parade spectators sit on bleachers in front of the first Antlers Hotel in August 1897 as a float with a medieval theme rolls by. The horses are draped in cloth to simulate armor, as are the men. These parades, held to attract tourists, traversed Cascade Avenue in the years surrounding the turn of the century, becoming more elaborate as time went by. They were eventually replaced by the Pikes Peak or Bust Rodeo.

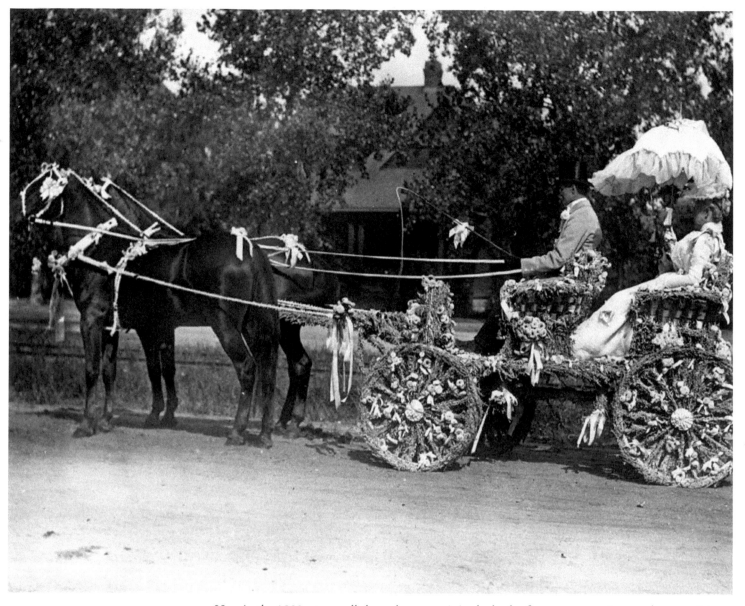

Here in the 1890s, two well-dressed women sit in the back of a two-seat carriage ready to participate in the Flower Parade. Various vehicles adorned with live flowers and greenery joined bands and military units in these events.

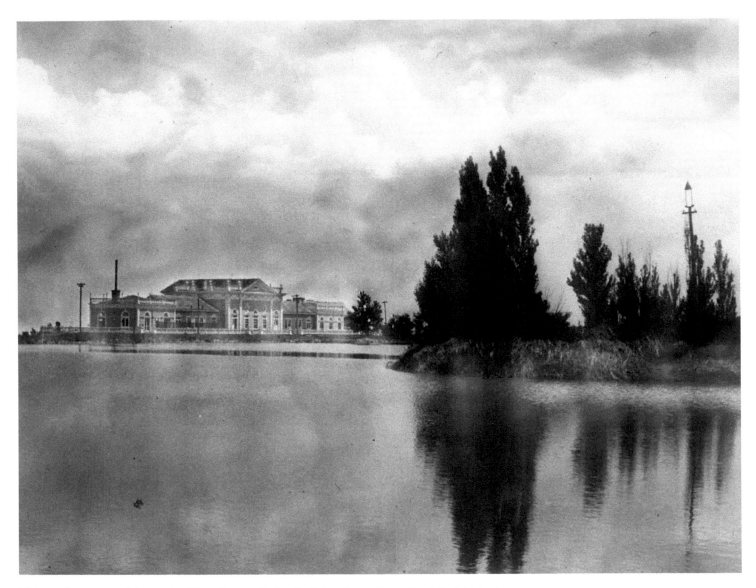

This is a long view of the original Broadmoor Casino built by Count Pourtales. The lake in the foreground is manmade. A note on the original photograph says, "Opened in 1891—burned 1897." The Count began his business with a dairy farm and went on to build the casino and work toward building a small community. Spencer Penrose continued the work years later, constructing the Broadmoor Hotel, a five-star establishment surrounded by upscale homes.

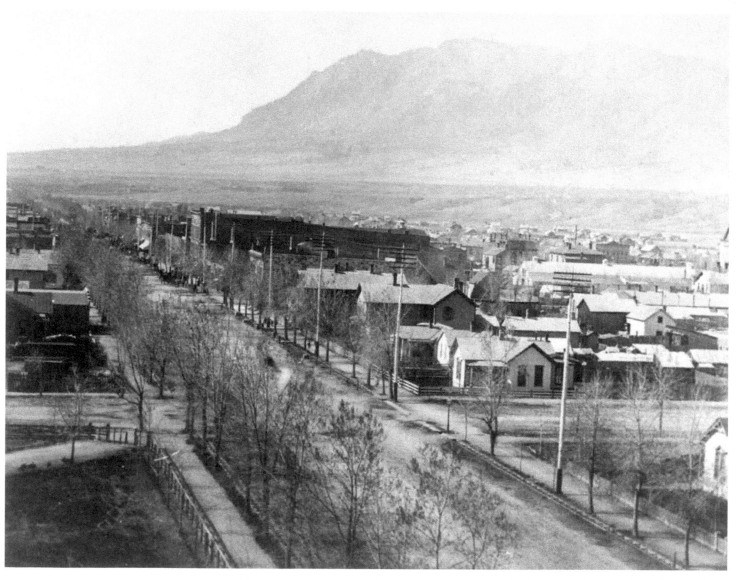

This is a view of a residential street facing south toward Cheyenne Mountain. The El Paso Canal drainage ditches are visible along each side of the street. The canal brought Fountain Creek water to downtown and north-end residential areas for trees and lawns. General Palmer paid 50 cents each to have small, broad-leafed trees planted throughout the city in the 1870s. Shown here half-mature, they have been growing for some years.

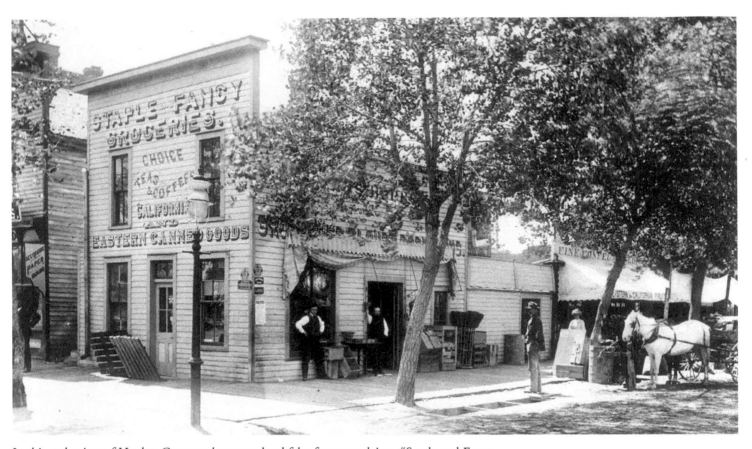

In this early view of Hughes Grocery, the upper-level false front proclaims, "Staple and Fancy Groceries. Choice Teas & Coffees. California and Eastern Canned Goods," an ostentatious appeal to settlers wanting more than rough frontier foodstuffs. Next door to the left, "decorative paper hanging" services are for hire.

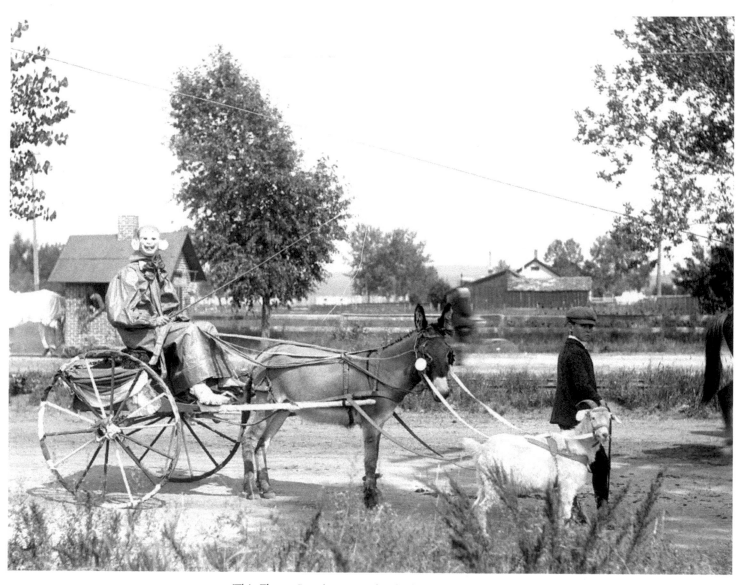

This Flower Parade entry is hitched to a burro and a goat. Flower parades were a big tourist draw during this era.

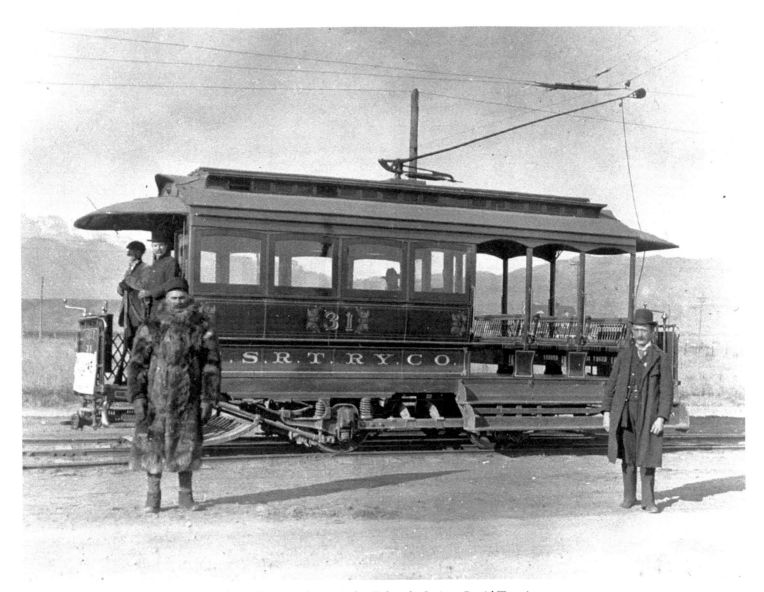

The old Colorado Springs Manitou Railway Company became the Colorado Springs Rapid Transit Railway Company around the end of the century, when W. S. Stratton put $2,000,000 into the company for electricity, better tracks, better cars, expanded routes, employee benefits, and new blue uniforms. The railway ran under various names until 1932 when Colorado Springs bus service began. The new service and an increase in automobile travel put an end to the streetcar system.

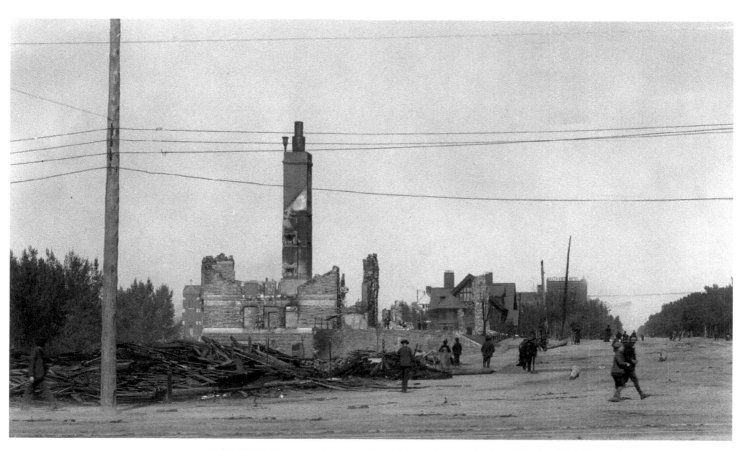

This 1898 photograph shows the ruins of the first Antlers Hotel, which burned in October that year. Passersby inspect what remains of the once grand accommodations. The original hotel cost $125,000 to build, a hefty price tag in the 1890s, but General Palmer was not fazed by the calamity. An improved Antlers Hotel was soon under construction at the same location on Cascade Avenue.

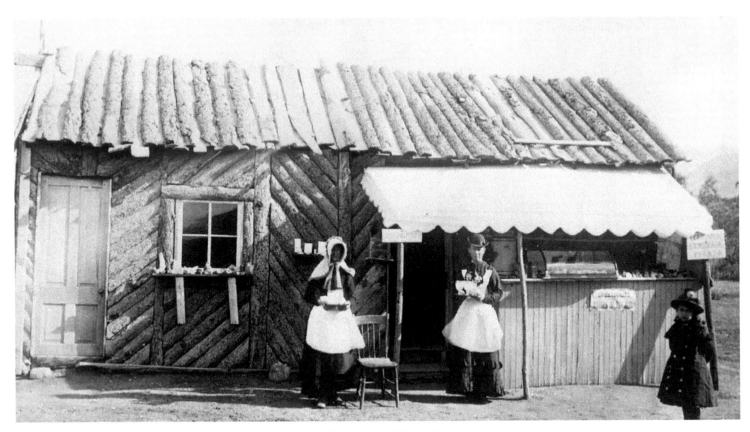

Women in aprons and caps and a young girl stand in front of a rustic building with an awning in the Garden of the Gods in 1897. For sale are tonic beer, iced milk, lemonade, cigars, and specimens from the Garden of the Gods. Notes on the original photograph say, "Left side of Garden Road coming from Mesa to Gateway Rock," indicating that the locale was close to today's entrance to the park from 30th Street.

BOOM TIMES

(1900–1919)

This is the second Colorado City city hall, built in 1892. Located at 115 South 26th Street, it held offices, a jail, and a fire station, and over the years served as home to a commercial stable, a gym, and various businesses, including the Colorado Springs Mattress Company. In 1917, Colorado City was annexed by the city of Colorado Springs. John Bock, a city pioneer, purchased the building and turned it into a museum of western artifacts. When the museum fell on hard times, the contents were sold at auction and today are housed primarily at the Old Colorado City History Center. The building burned in the 1980s. Today Old Town Guest House Bed and Breakfast occupies the site.

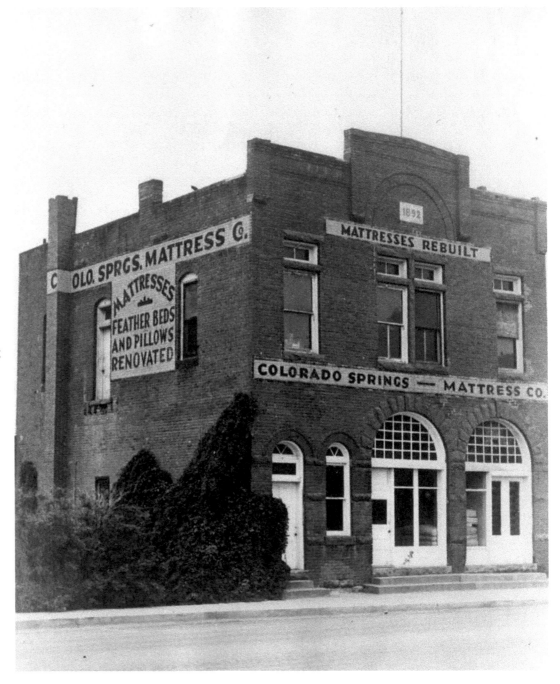

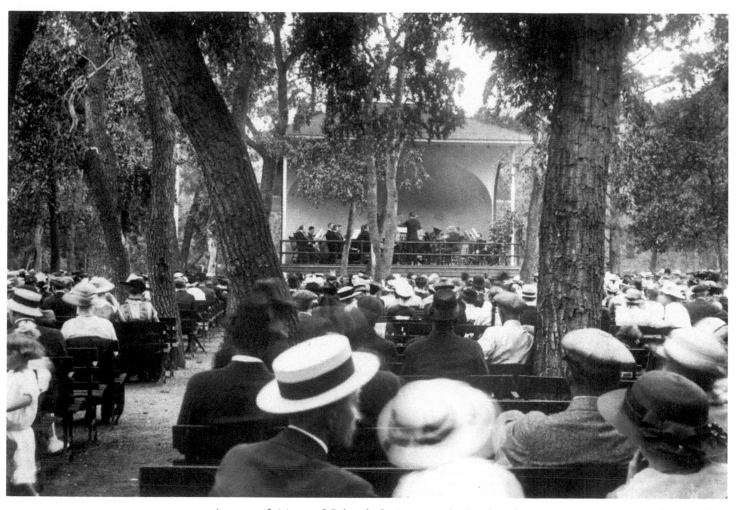

A group of citizens of Colorado Springs attend a Sunday afternoon summer concert at Stratton Park near the confluence of North and South Cheyenne creeks. W. S. Stratton, the carpenter who became a gold king, gave the park and the concerts to the city for the ordinary family to enjoy. The band concerts each summer cost Stratton approximately $4,000. Floods and neglect have taken their toll— today few traces of the park remain.

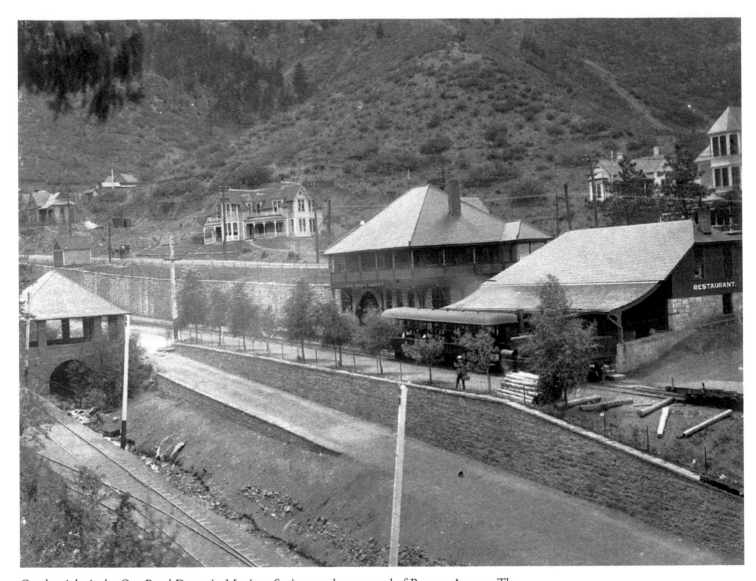

On the right is the Cog Road Depot in Manitou Springs at the west end of Ruxton Avenue. The tracks in front are for the streetcar line.

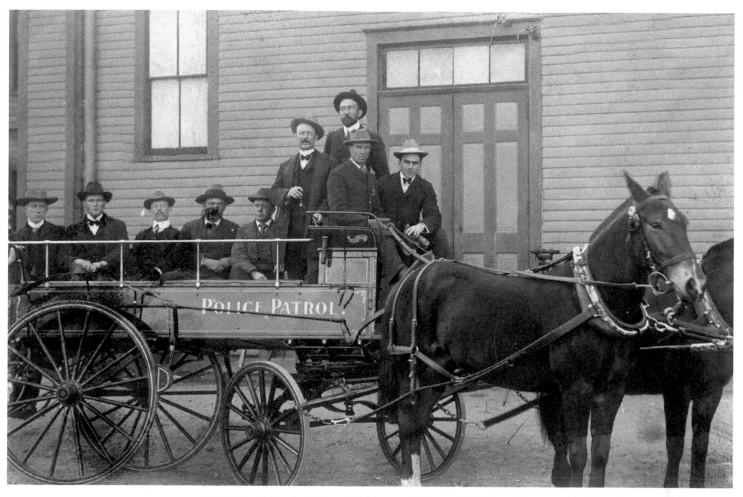

In 1901, Colorado Springs, by law, was designated a "first-class city," which made possible an upgrade in the police force. The first police chief was hired (previously a constable and then marshal) along with 2 drivers, 2 detectives, 1 sergeant, 1 captain, and 10 patrolmen. The 10 men in this patrol wagon are probably the new patrolmen, each of whom worked 12-hour shifts and enjoyed one day off a month.

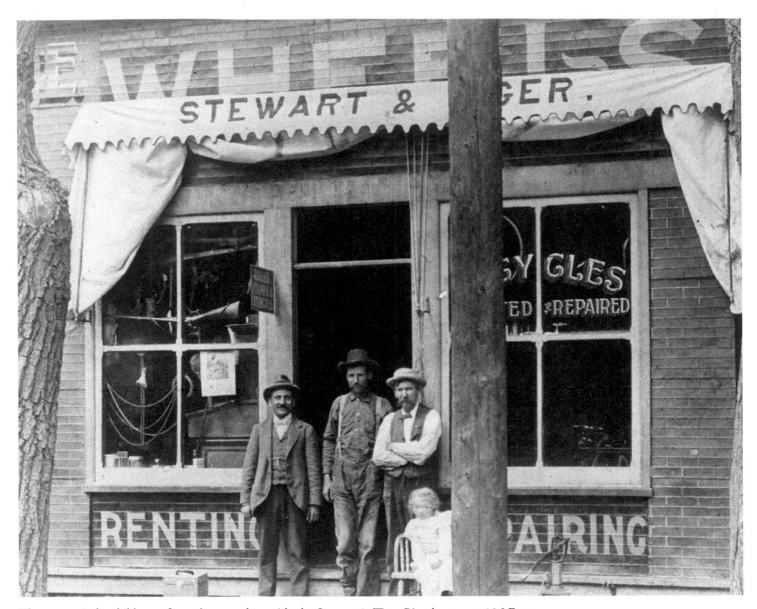

Three men and a child pose for a photograph outside the Stewart & Tiger Bicycle store at 106 East Huerfano (later Colorado Avenue) in 1901. Expensive toys for the well-heeled when first invented, bicycles became an inexpensive method of transportation, although difficult to use during Colorado winters.

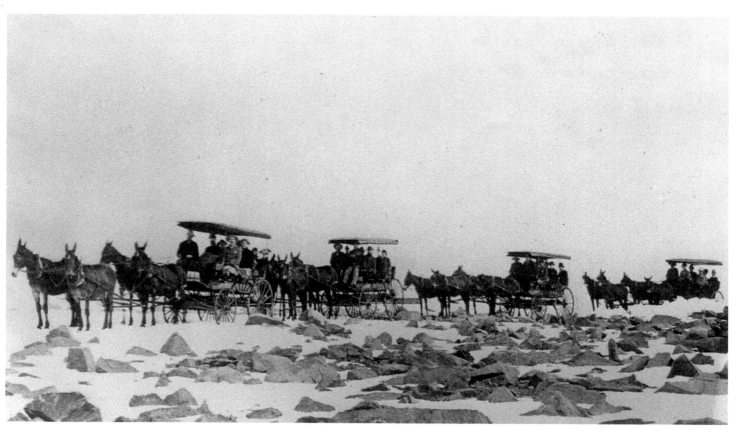

In 1901, four mule-drawn wagons with six to eight people in each pause in snow and rocks on the old carriage road up Pikes Peak. John Hundley promoted these day tours, which departed the Midland Railroad station in Cascade each morning.

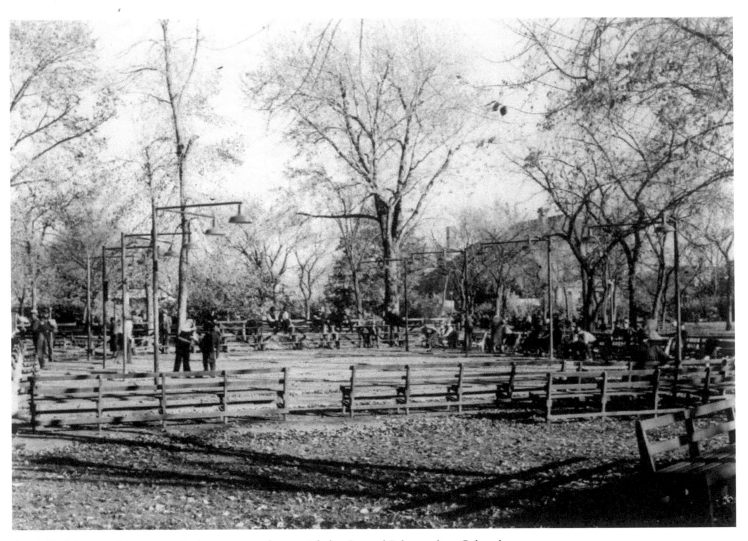

Acacia Park is one of the two main downtown parks set aside by General Palmer when Colorado Springs was founded. People are shown here playing shuffleboard in the early 1900s while spectators look on from wooden park benches. Shuffleboard can still be played in this park today.

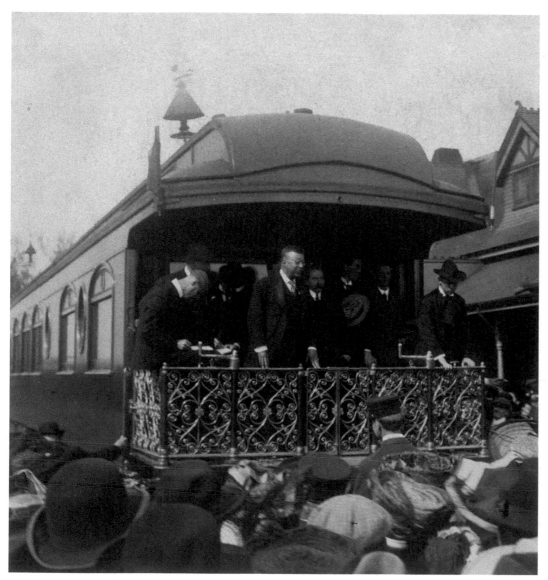

President Theodore Roosevelt speaks to the crowds during a visit in 1905. He had come to the area to hunt big game, but found time for other activities, including a visit with Dr. Donaldson, a former member of Roosevelt's Rough Riders. The much-admired president was back in Washington, D.C., around May 8.

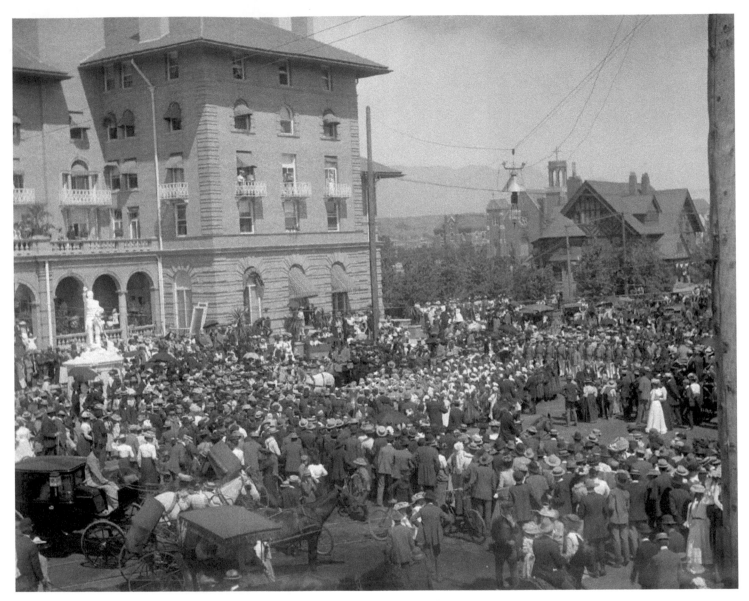

President Roosevelt waves to the crowd from a carriage in front of the second Antlers Hotel, near a statue of Zebulon Pike (at far-left, with Roosevelt's carriage to the right). Americans of the era used umbrellas, visible in this image, to shield themselves not only from rain but also from the sun.

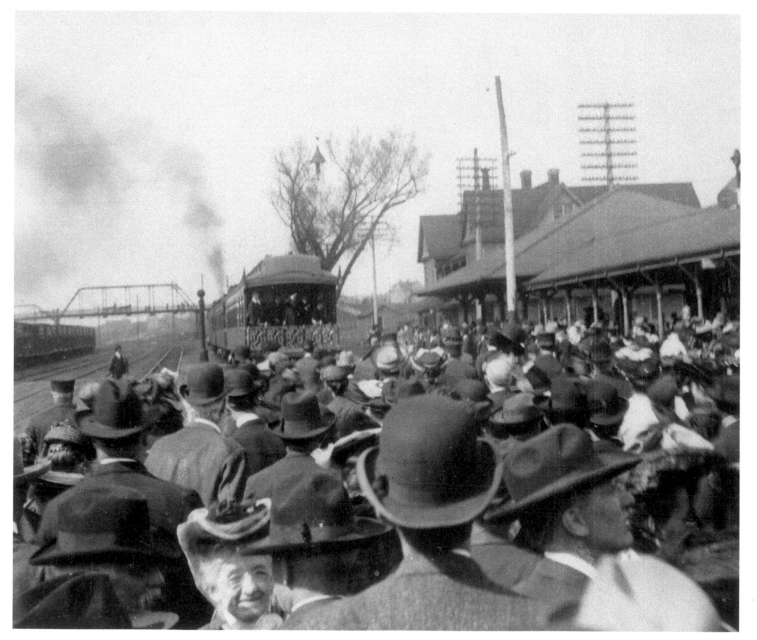

Roosevelt departs Colorado Springs in 1905 aboard his special railroad coach. That same year, always concerned for wilderness areas like those he found in the West, Roosevelt urged Congress to create the U.S. Forest Service to manage government-owned forest reserves.

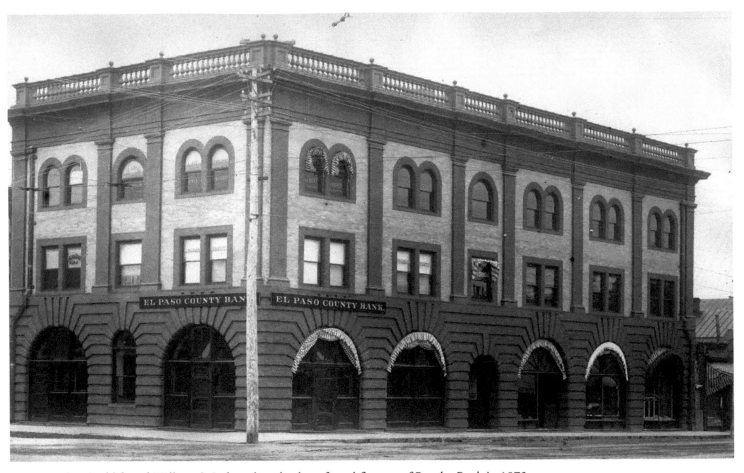

General Palmer's old friend William S. Jackson bought the safe and fixtures of Peoples Bank in 1873 and opened the El Paso County Bank along with D. H. White and J. S. Barbour. The three-story stone-and-brick building, at the southeast corner of Pikes Peak Avenue and Tejon Street, is shown here in the early 1900s. The bank featured arched windows, awnings, and a flat balustrade roof. Several businesses, along with the bank, were housed in the building.

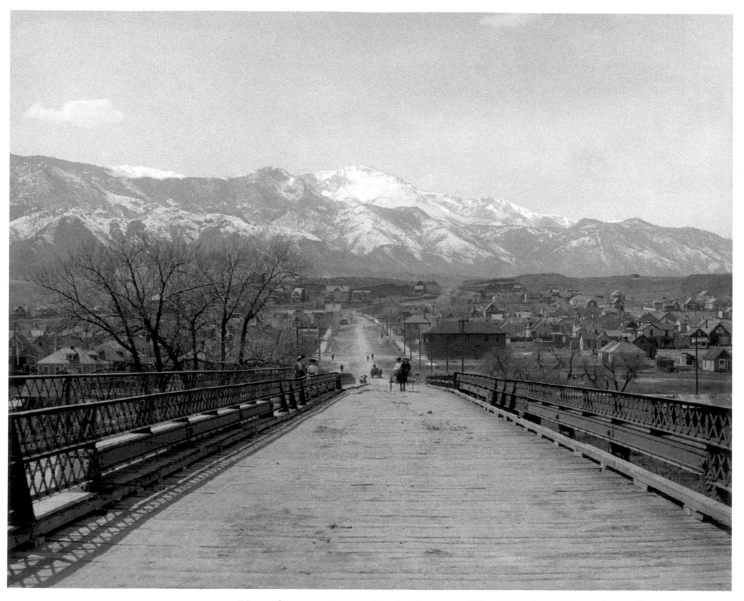

Horse-drawn carriages and pedestrians cross West Bijou Avenue's wooden viaduct in downtown Colorado Springs, as snow-covered Pikes Peak towers upward from behind. During the great 1935 flood, Monument Creek waters would wash this bridge away.

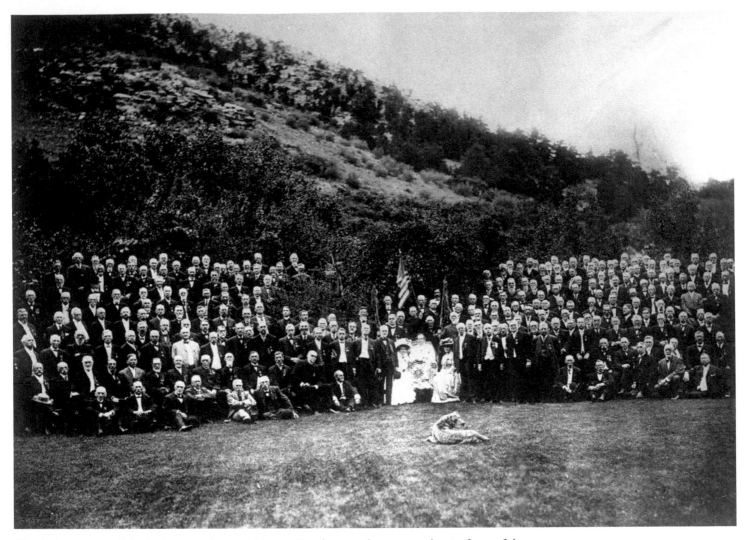

Civil War veterans of the 15th Pennsylvania Volunteer Cavalry pose for a group shot in front of the rocks at Glen Eyrie in 1907. A paralyzed General Palmer sits at center with his daughters at his side and one of his Great Danes on the ground in front. Unable to travel following his riding accident the year before, General Palmer hosted the reunion at Glen Eyrie and at the Antlers Hotel.

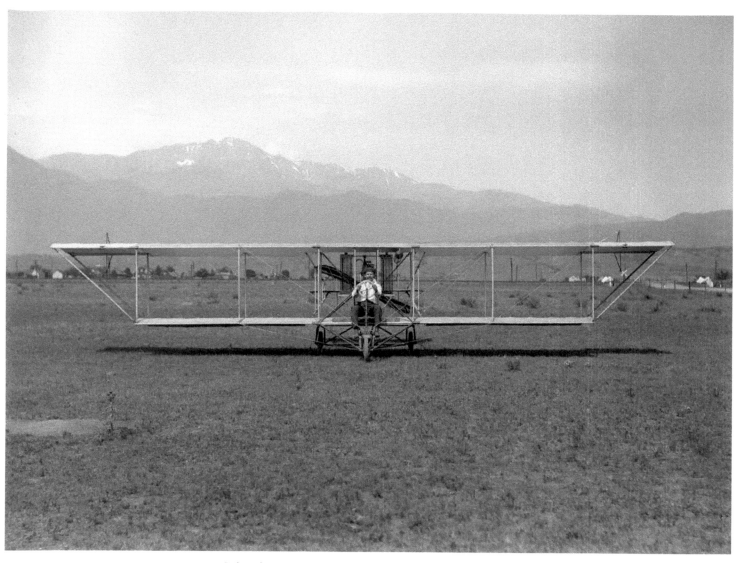

Colorado Springs has had a long relationship with flying. In this view, W. E. Bowersox prepares for flight in a field near the city. Early aircraft designs put the engine and propeller behind the pilot, whose open-air "cockpit" consisted of nothing more than a seat and a steering wheel. At one time, Manitou had a campground and cottage city with an airfield attached called McLaughlin. In the 1920s, Alexander Aircraft Company developed the Eaglerock biplane. These accomplishments would clear the way to selecting the city as home to the U.S. Air Force Academy in the 1950s.

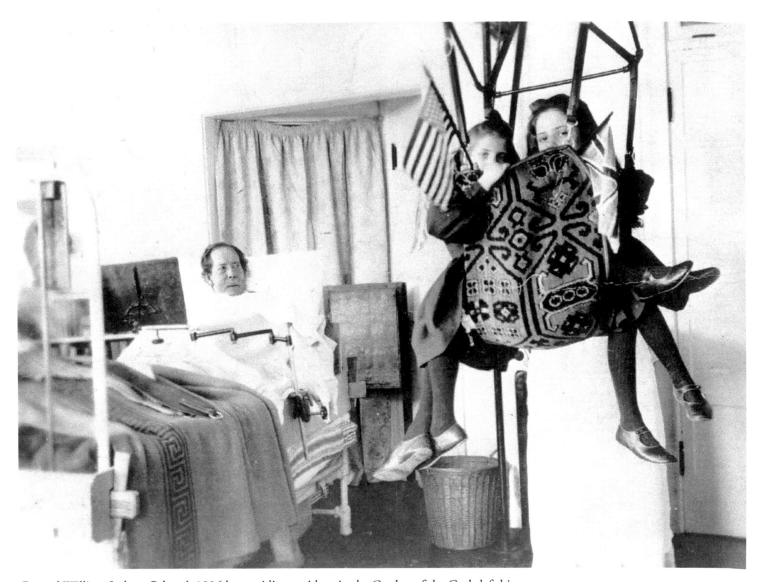

General William Jackson Palmer's 1906 horse-riding accident in the Garden of the Gods left him paralyzed. During the next three years, he tried to maintain some measure of a normal life. Because of his paralysis, he bought a car, hired a driver, installed a waterbed for comfort, and brought his Civil War unit to Colorado Springs for a reunion. Here he watches his grandnieces dangle from a sling attached to the ceiling.

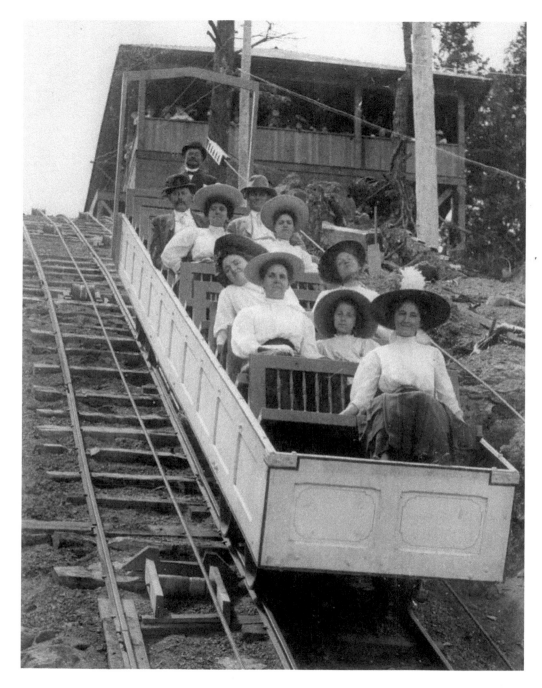

In 1908, ten passengers sit in an open car on the Incline Railway, which ran from the depot at the west end of Ruxton Avenue in Manitou Springs, up Mount Manitou where it connected with the Barr Trail for hikers. Built in 1907 to haul pipe to a water plant, the incline traveled a 41 percent grade. In 1915, Spencer Penrose purchased the tourist attraction. The incline closed in 1990 and the tracks were removed, but the long scar on Mount Manitou, which tops out at 9,439 feet, remains visible.

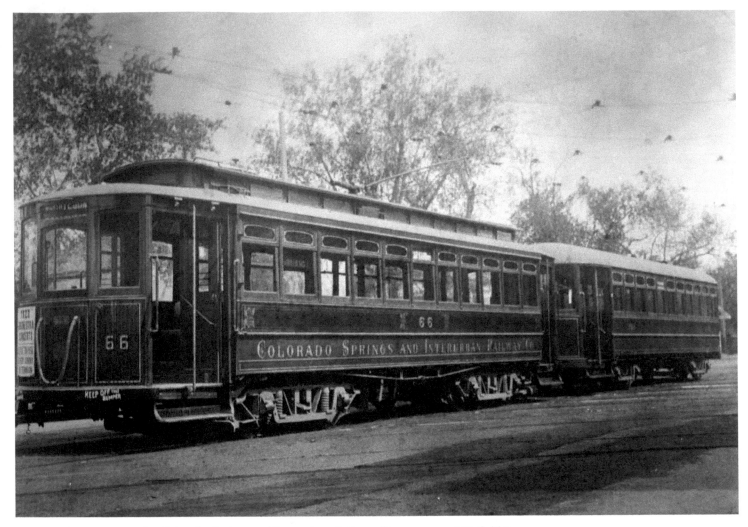

In service here in 1911, the Colorado Springs and Interurban Railway Company was Winfield Scott Stratton's expanded version of the original streetcar system. A caution on car no. 66 at front says "Keep off This Bumper."

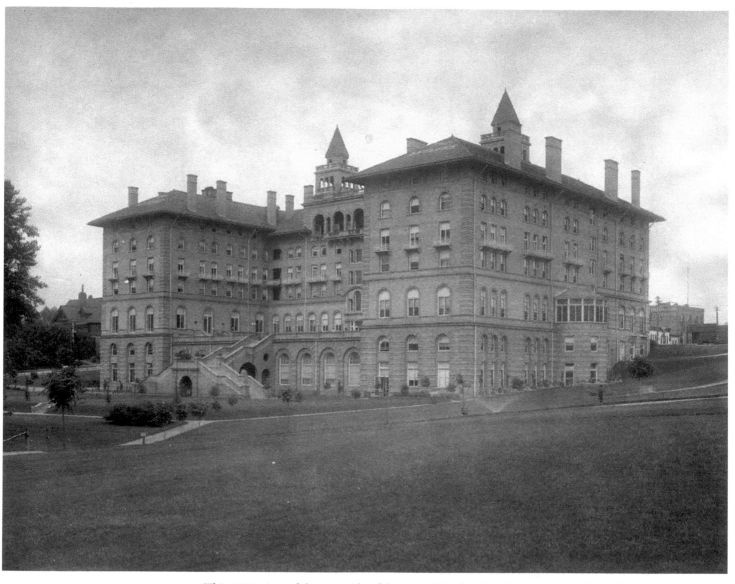

This 1910 view of the west side of the second Antlers Hotel shows the brick-and-stone structure with hipped-gable roofs, chimneys, towers, bays, arched windows, a solarium, a terrace, stairways, a loggia, and landscaped lawn with new trees, sidewalks, and even sprinklers. This is the view of the hotel that guests saw as they arrived at the Denver and Rio Grande depot across the park.

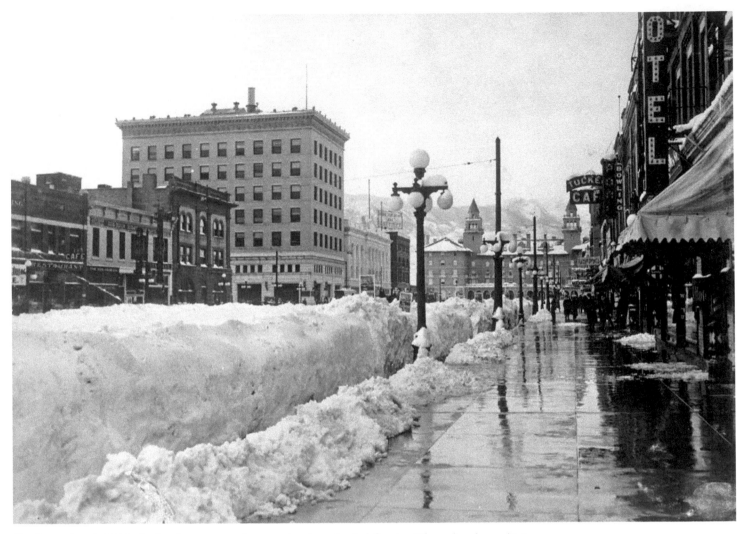

On December 4, 1913, the local newspaper forecast clouds and a few flurries. Three days later, 45.5 inches of snow lay on the ground. Streetcar service was suspended, and horses, sleighs, and snowshoes became the most reliable modes of travel. In this photograph, sunshine has begun to melt snow from the sidewalks.

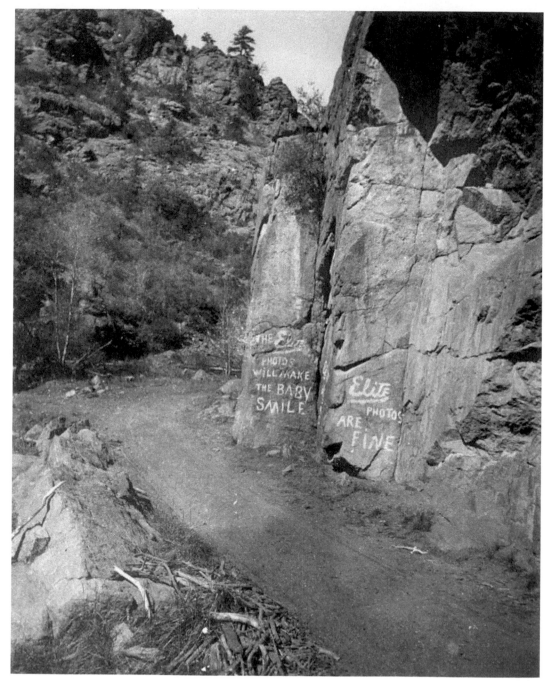

Advertising in the form of graffiti appeared one year on the rocks in William Canyon near the Cave of the Winds. The canyon must have echoed as passersby pronounced, "Elite Photos Are Fine" and "The Elite Photos Will Make the Baby Smile."

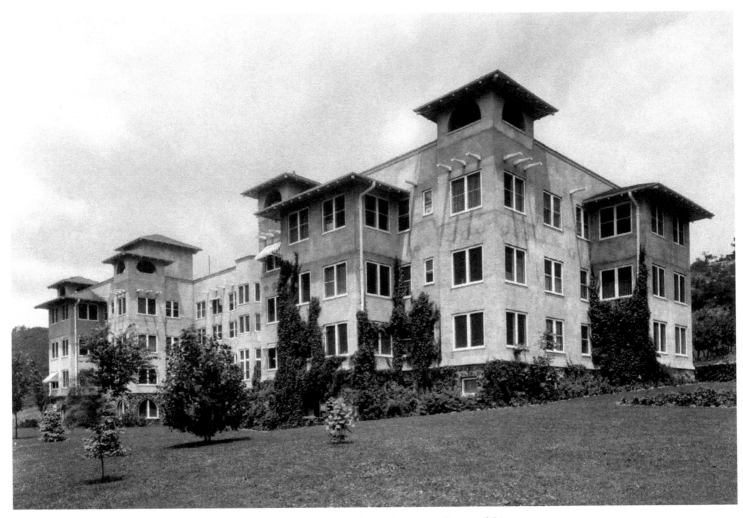

This is a side view of the main building of Cragmor Sanatorium. The facility catered to wealthier tuberculosis patients. These buildings are now a part of the University of Colorado at the Colorado Springs campus.

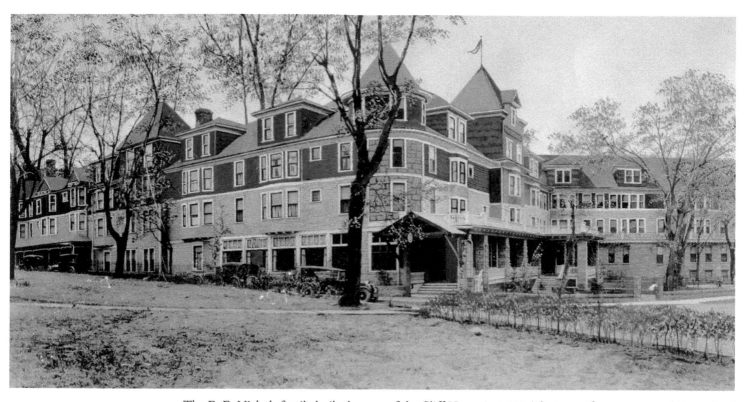

The E. E. Nichols family built the core of the Cliff House in 1873. The magnificent structure has survived economic difficulties, urban renewal, and fire, and stands today a remodeled gem of Americana in Manitou Springs.

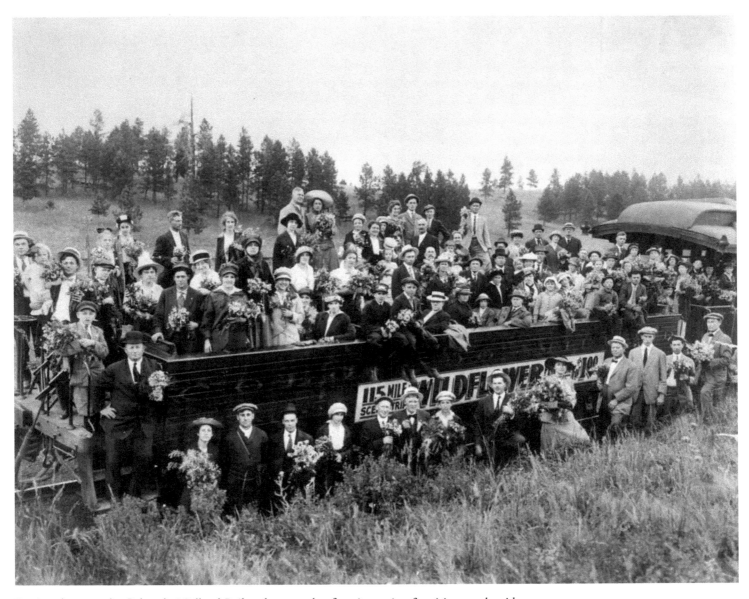

During the years the Colorado Midland Railroad operated, a favorite outing for visitors and residents alike was the midsummer wildflower excursion. The trip was usually an all-day event with people returning home with armloads of wild alpine flowers. This group displays their dainty pickings in 1915.

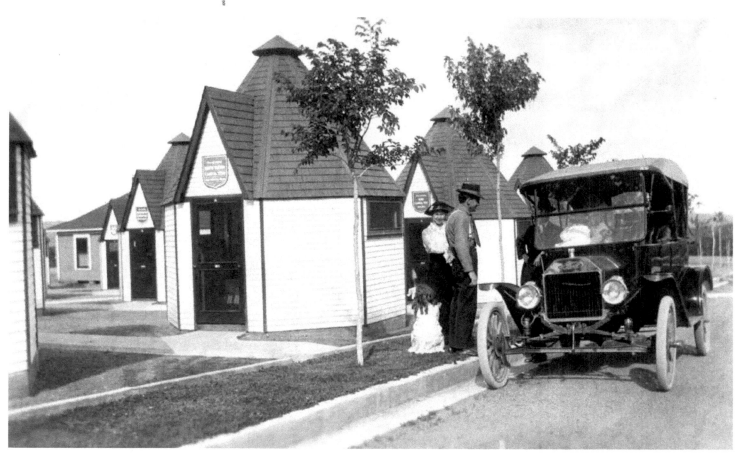

The Woodmen of America purchased 1,000 acres of land to set up one of the largest sanatoria in the area. Patients were housed in Gardiner tent cottages (seen here). The sanatorium was a self-contained community with a complete infrastructure—paved streets with curbs, grass, trees, electricity, a water system, and more. The Woodmen Sanatorium in Woodmen Valley grew as the TB cure rate increased. It closed in the 1940s when antibiotics became highly effective as a treatment.

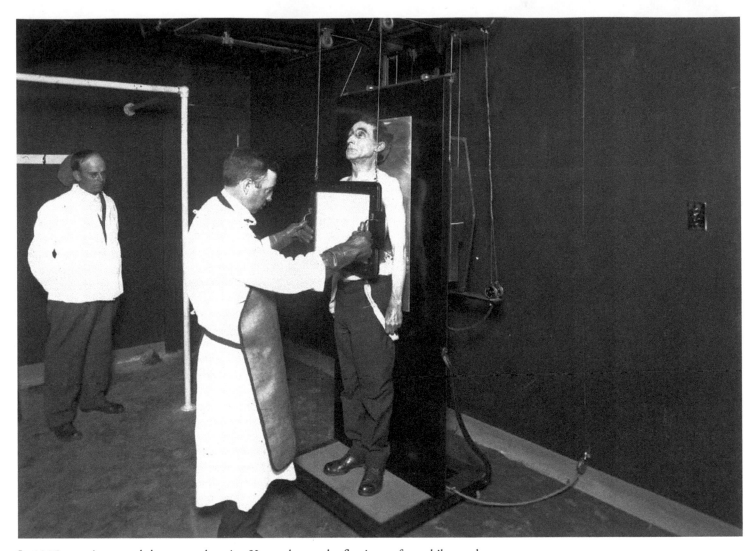

In 1915, a patient stands between a hanging X-ray plate and reflective surface while another man in lead apron and gloves positions the plate. With the newly developed machine, tuberculosis could now be diagnosed but a cure would not be discovered until 1943. Once known as consumption, the infectious bacterial disease was widespread throughout human history and before the advent of sanatoria it was almost always fatal. Its resurgence in recent years, in strains resistant to antibiotics, has been widely publicized. Cautionary pleas to the public to complete antibiotics prescriptions for maladies of any kind, to help prevent the spread of antibiotics-resistant pathogens, have also been issued.

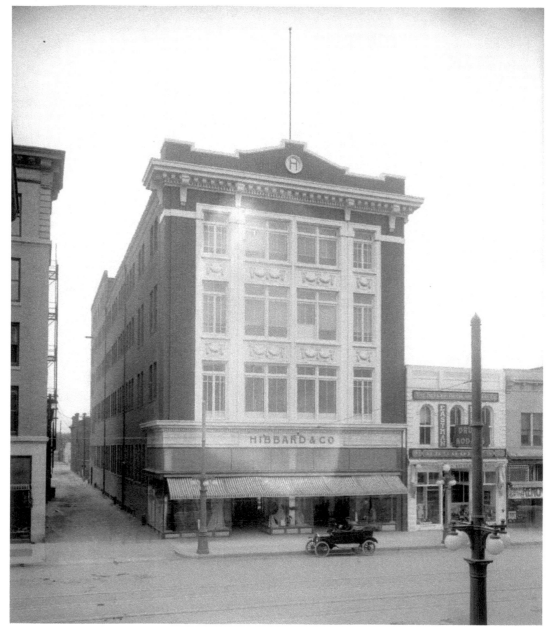

Shown here in the 1910s, Hibbard's Department Store at 17 South Tejon was the most complete place to shop in Colorado Springs beginning in the early 1900s. It featured wooden floors, bright display cases, a hand-operated elevator, and pneumatic tubes for sending money to a central cashier upstairs. Hibbard's closed in the 1990s, and today the building is occupied by restaurants.

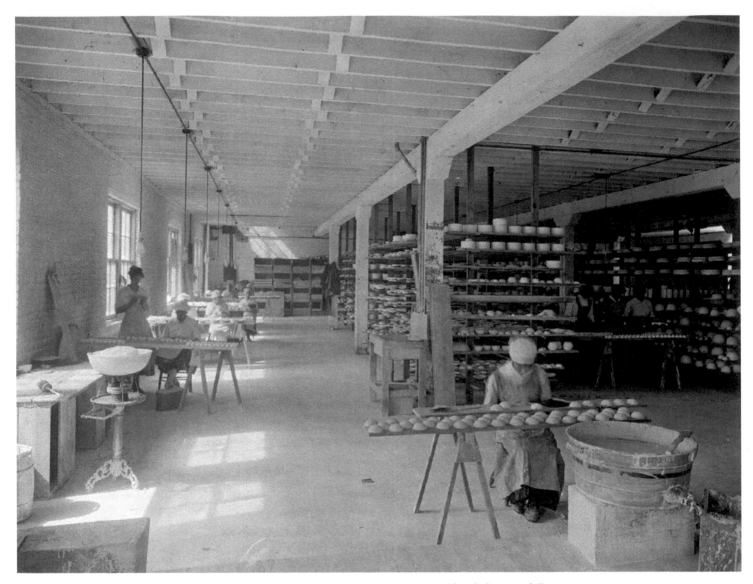

Women are shown at worktables at the Van Briggle Memorial Pottery about 1910. The shelves are full of bisque ceramic pieces. The woman in front with a large tub of water is probably smoothing out the seams of the green ware.

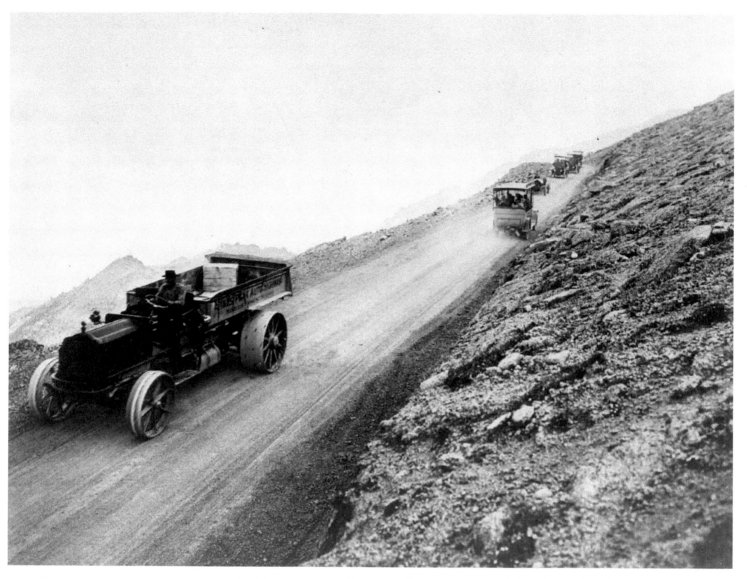

At right, a line of touring cars and one racecar ascend the Pikes Peak Highway auto road. At left, a truck lettered with the words "Pikes Peak Auto Highway, World's Highest Highway" pursues its journey downslope. A note with the original photo dates the scene to the summer of 1916, the year the auto highway opened. Today the road is closed to tourist travel when the Pikes Peak Hill Climb race is in progress.

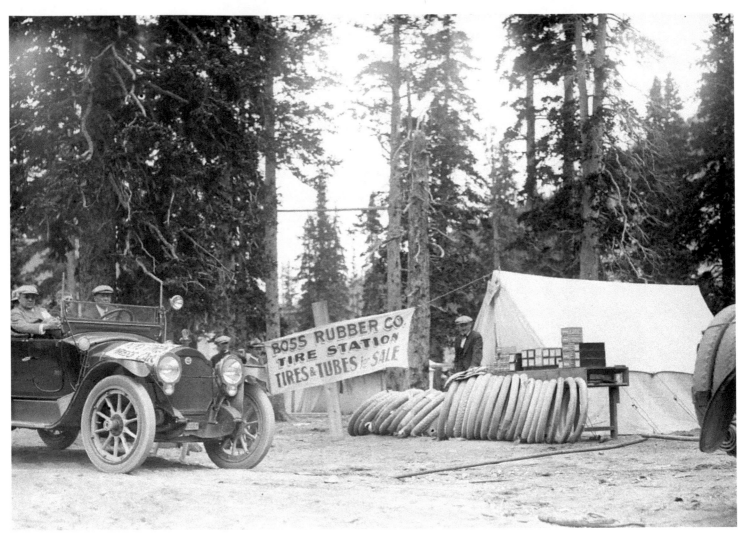

A Packard Twin Six used as the *Rocky Mountain News* press automobile is stopped at the tire station on the Pikes Peak Highway around 1915, where a large number of tires are stacked out front. Clear evidence that the remote road was very hard on tires.

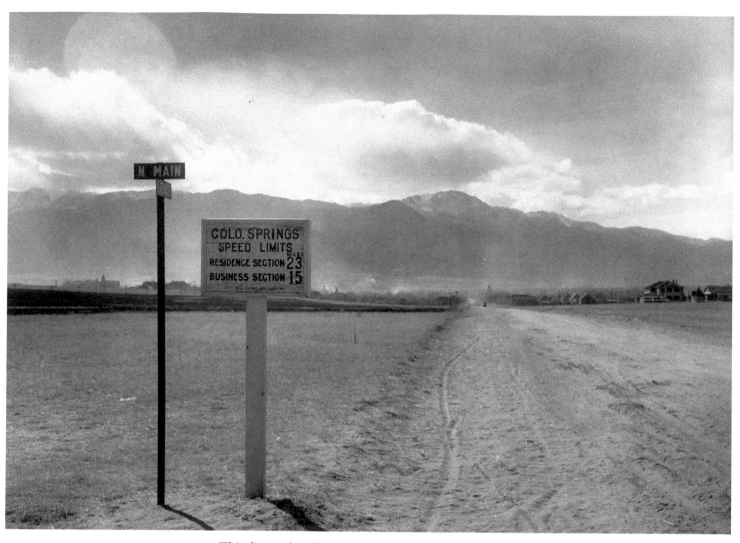

This dirt road on the edge of town faces Pikes Peak with houses in the distance. A street sign in the foreground identifies it as the corner of North Main and East Platte. The speed limit here in the 1910s was 23 M.P.H. on residential streets, 15 M.P.H. on business streets.

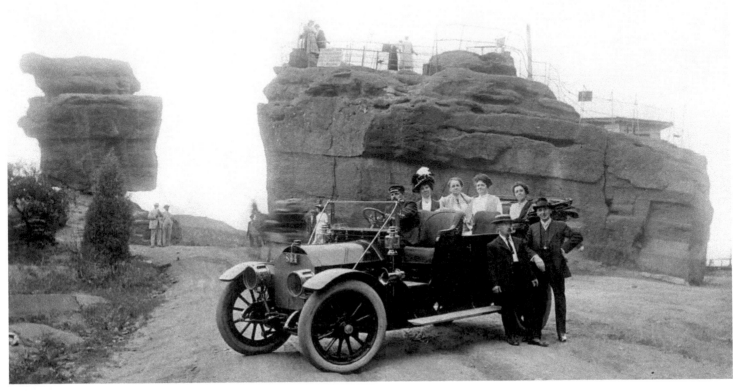

A car filled with tourists is parked in the Garden of the Gods near Balanced Rock. Until recent years visitors were allowed to climb to the top of the rock to view Steamboat Rock just opposite. The sign on top says, "Steamboat Rock Observatory. Use of the Telescopes Free to the Visitors. All Welcome." The old sandstone stairs and metal railings once used by tourists are still visible today.

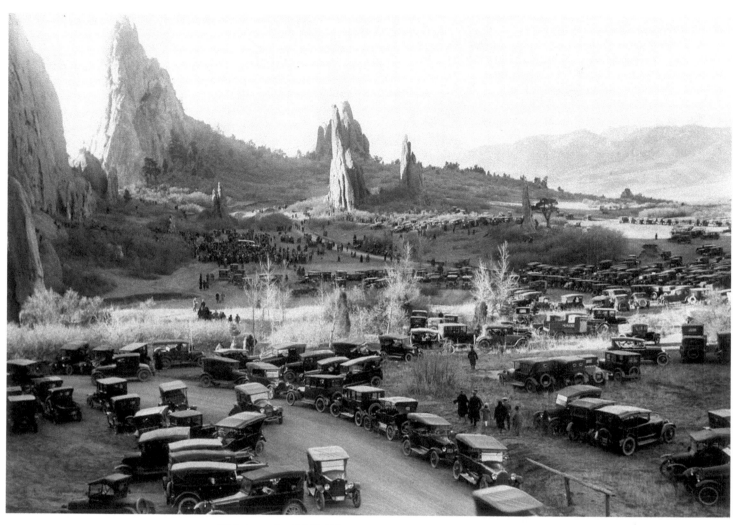

This is an April 1924 Easter sunrise service in the Garden of the Gods. Various churches in the city sponsored the annual event until the early 2000s, when the services were discontinued.

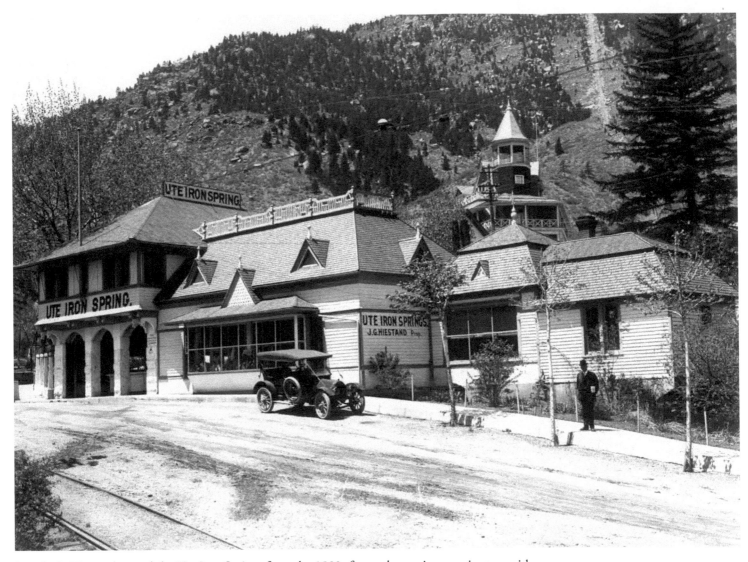

Joseph G. Hiestand owned the Ute Iron Springs from the 1880s forward, running a curio store with photographs there until his death. Hiestand consistently added on to the structure, which is shown here as it appeared in 1916. The track in the foreground is for the Manitou Electric Railway or the "Dinky Trolley" as it was called, and the Mount Manitou Incline is visible in the background.

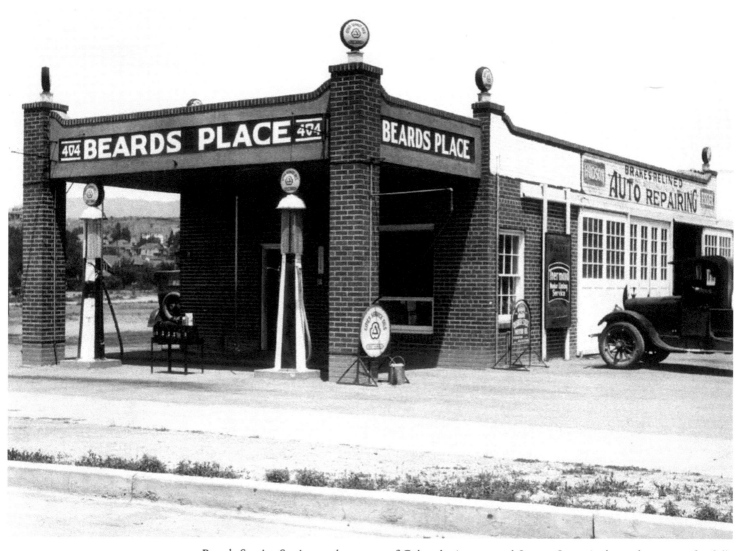

Beards Service Station at the corner of Colorado Avenue and Spruce Street is shown here open for full-service business. The station was located on the site of the 1916 prizefight between Charlie White and Freddie Welch during which bleachers holding 500 spectators collapsed.

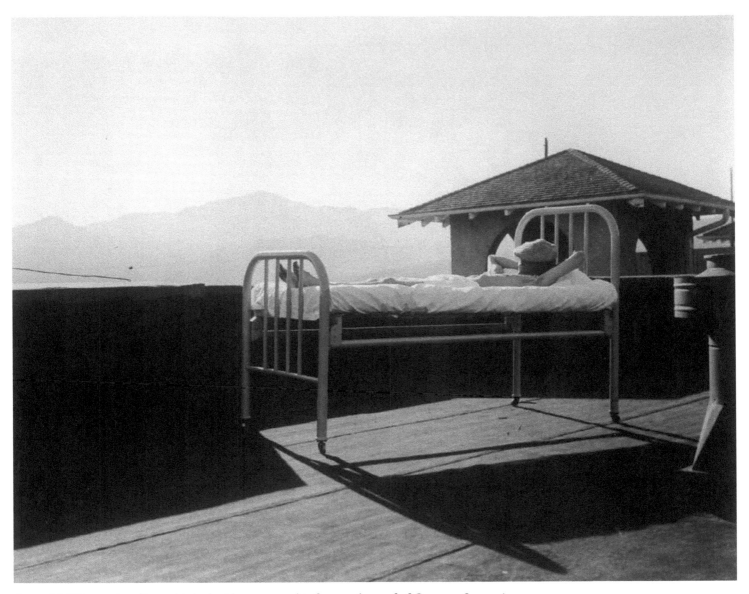

Around 1920, a patient lies on his bed with a cap over his face on the roof of Cragmor Sanatorium, with Pikes Peak visible in the background. He is taking a sunbath.

CHANGING TIMES

(1920-1939)

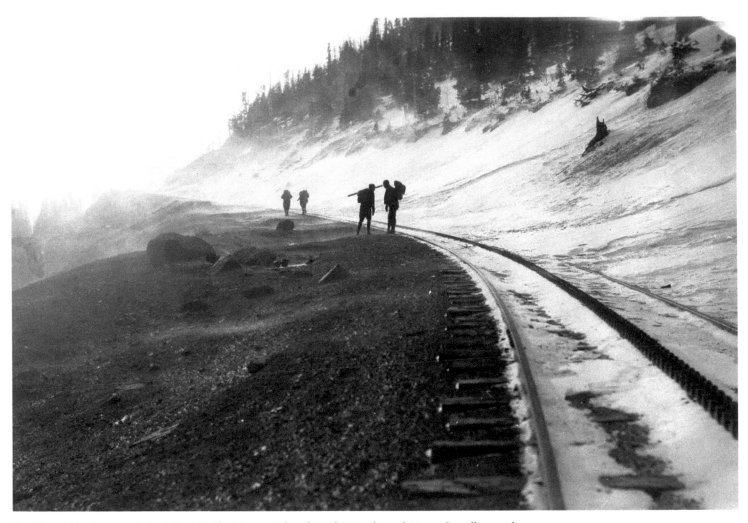

On December 31, 1922, Fred Barr, Willis Magee, Ed and Fred Morath, and Harry Standley made their first annual climb up Pikes Peak. These five are the founders of the AdAmAn Club, which has climbed Pikes Peak every New Year's Eve since 1922, setting off fireworks when it reaches the summit. Standley was the official photographer of the group as well as a member. Four of the five are shown here following the cog railroad track, while the fifth (Standley) takes the photograph. Each year one new member is added to the group.

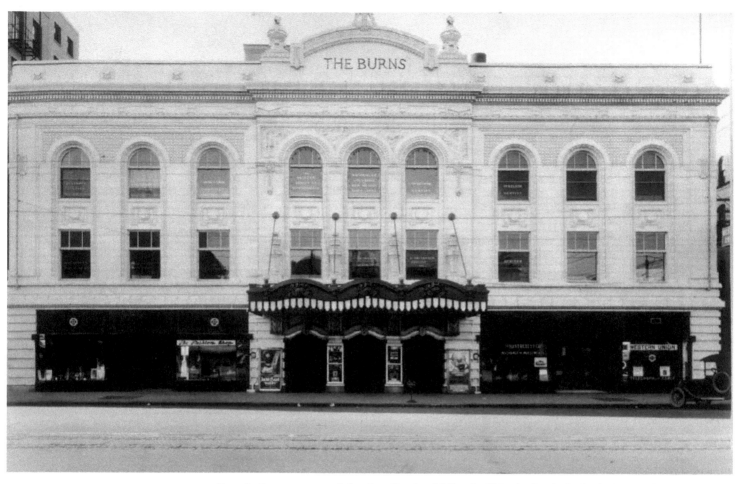

Jimmie Burns, owner of the giant Portland Mine in Cripple Creek, built the Burns Opera House in 1912 at a cost of $500,000. The Pikes Peak Avenue landmark is shown here in 1921.

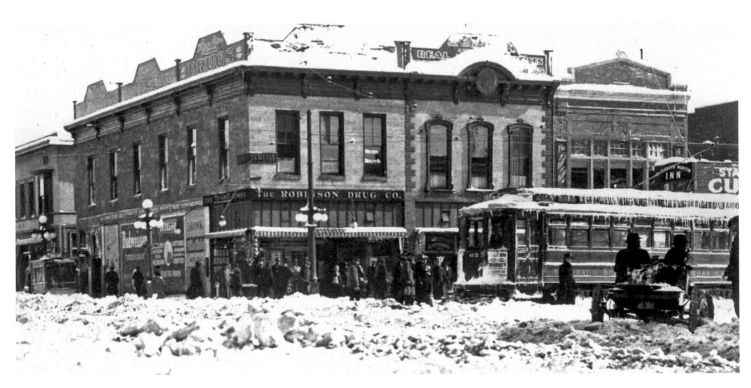

This is a view of the northeast corner of Pikes Peak Avenue and Tejon Street known as "Busy Corner," following the April 1921 snowstorm which dropped 15 to 20 inches of the white stuff on the area. "Meet me at Busy Corner" was a phrase commonly heard among early residents, some of whom are shown here boarding a snow and ice covered streetcar in front of the Robinson Drug Company.

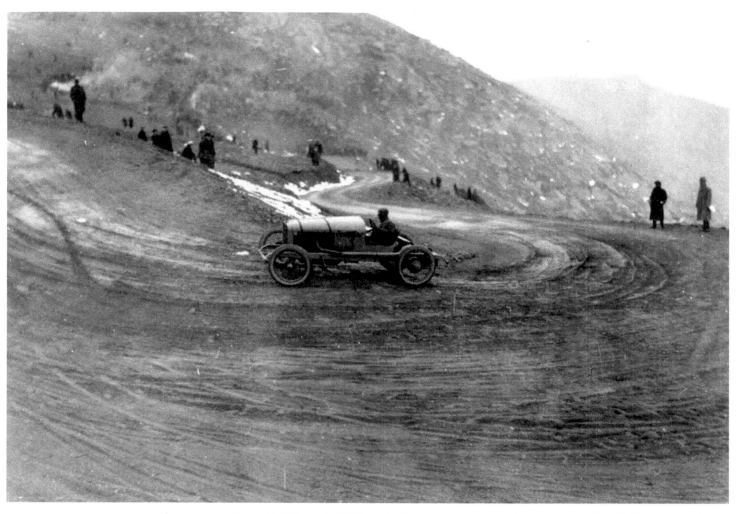

Henry F. O'Brien in his Templar Special spins around the curve at the Devil's Playground during the Pikes Peak Hill Climb in 1920. He finished eighth in the race. Templar Motors Corporation out of Lakewood, Ohio, made three types of autos—a sedan, a touring car, and two sporty versions. In business from 1917 to 1924, Templar produced a total of 6,000 units during its brief existence.

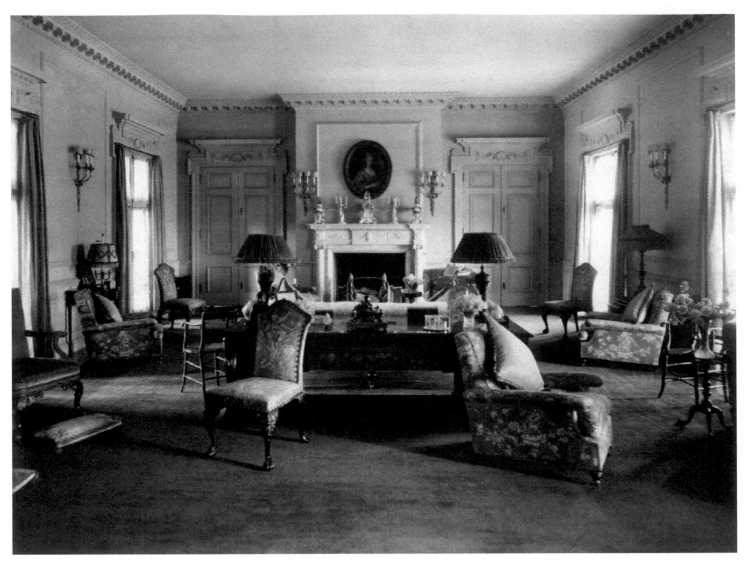

When gold tycoon and philanthropist Spencer Penrose and his wife Julie decided to move closer
to their beloved Broadmoor Hotel, they chose as their home El Pomar, an estate below Cheyenne
Mountain. This rectangular room has a fireplace flanked by two double doors, ornate plaster door,
window, and cove molding. Many celebrities have visited in this home including President and Mrs.
Calvin Coolidge, who spent their summer vacation at El Pomar.

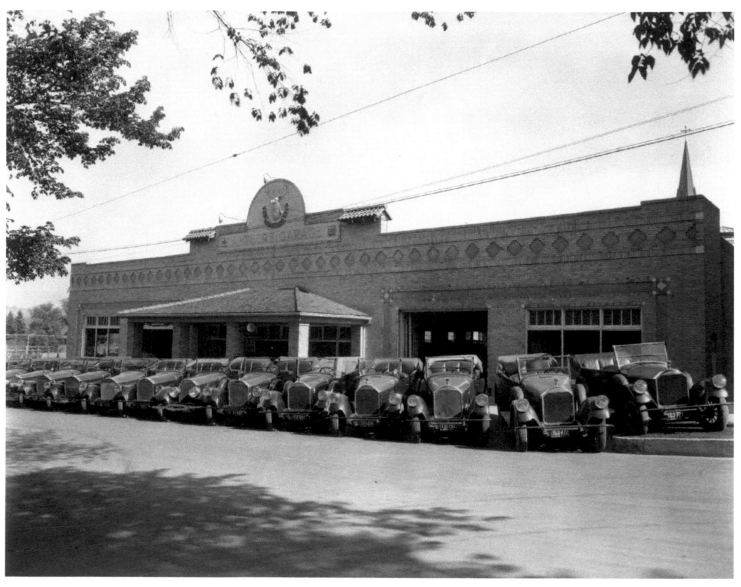

The Antlers Hotel Garage was located across Pikes Peak Avenue on the north side of the hotel. When the new Colorado Springs library and parking lot were built, the garage was demolished, but its facade, with bas-relief deer emblem made of Van Briggle tiles, was saved and used as the entrance to the library parking lot.

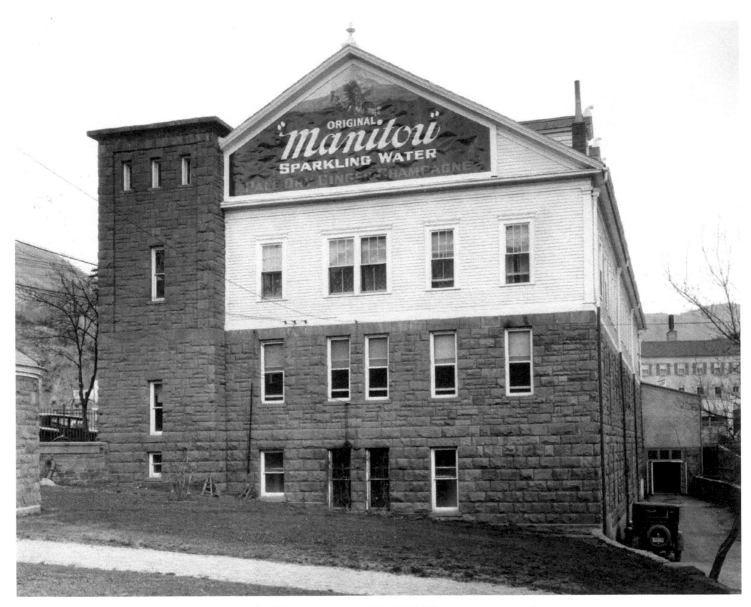

This is the Manitou Mineral Water Company building as it appeared in 1926. The company bottled and marketed the naturally carbonated mineral waters common to the area. It offered two internationally known specialties—Manitou Table Water and Ginger Champagne.

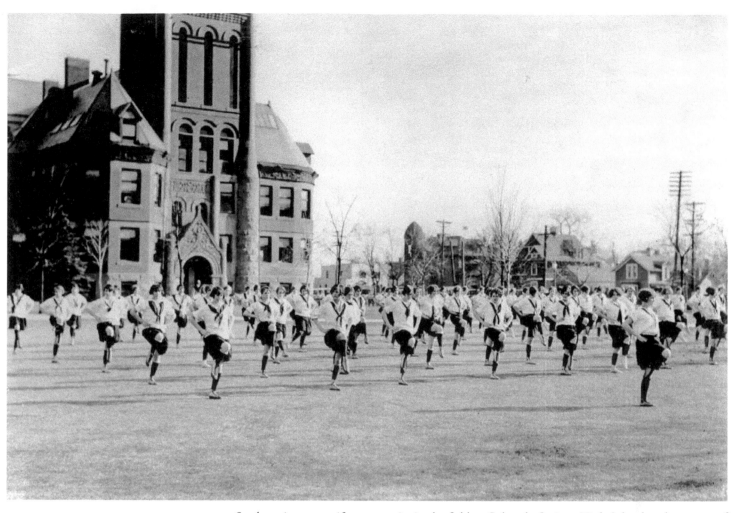

Students in gym uniforms exercise in the field at Colorado Springs High School at the corner of Nevada and Platte avenues in 1927. They are dressed in 1920s-style exercise clothing—white blouses with dark ties and dark bloomer pants. The old Colorado Springs high school was demolished in 1938 and rebuilt in a more modern style the next year.

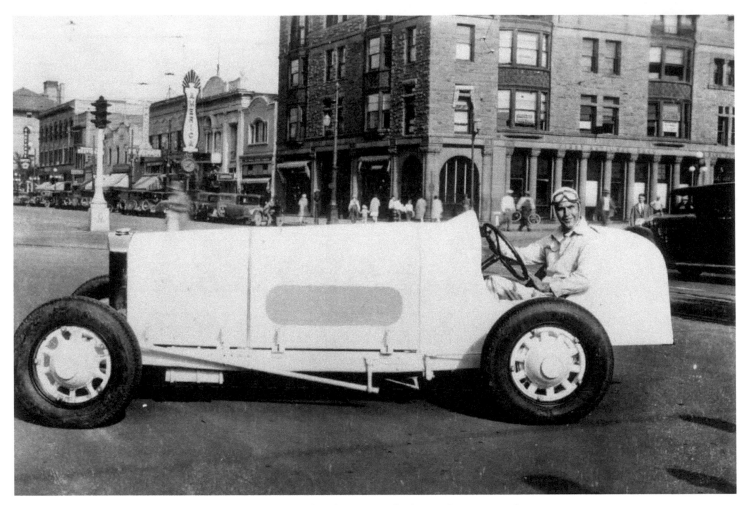

Louis Unser is shown sitting in his Coleman FWD Special at the corner of Pikes Peak Avenue and Tejon Street in downtown Colorado Springs during Pikes Peak Hill Climb race week activities in 1930. A caption accompanying the original photograph quips, "Did I take the wrong turn?" Three Unsers regularly participated in the "Race to the Clouds."

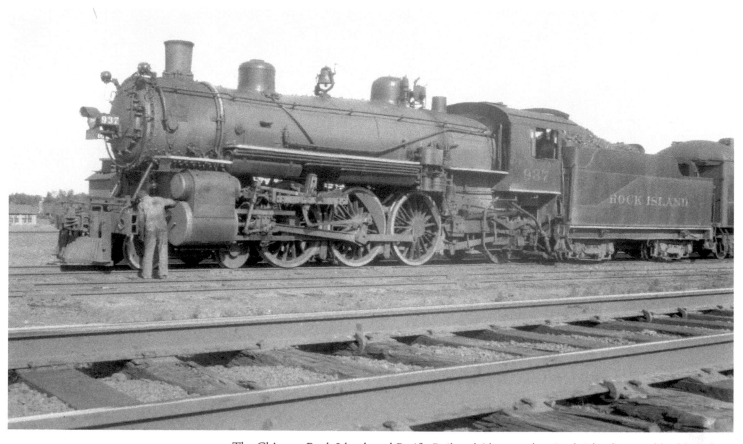

The Chicago, Rock Island, and Pacific Railroad (shortened to Rock Island) started building from Topeka, Kansas, toward the Rocky Mountains in 1888. When the railroad decided to make Colorado Springs their western terminus, the town erupted in celebration. This 1929 photograph shows coal-fired steam engine no. 937, a 4-6-2 wheel, on the tracks.

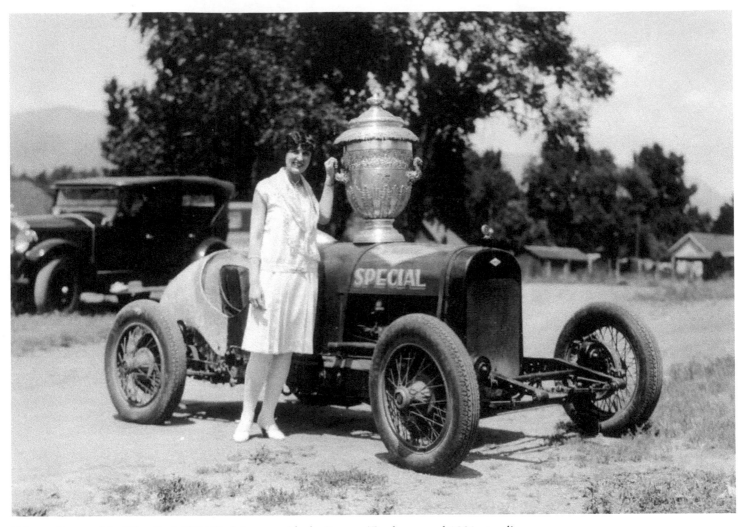

Princess Power of the Pikes Peak Hill Climb is seen with the Penrose Trophy around 1931, standing beside a Paige Special racecar. The trophy is named for Spencer Penrose, who established the automobile race in 1916. Many famous drivers have been attracted to the race including Barney Oldfield, Rick Mears, Parnelli Jones, Mario Andretti, and several Unsers.

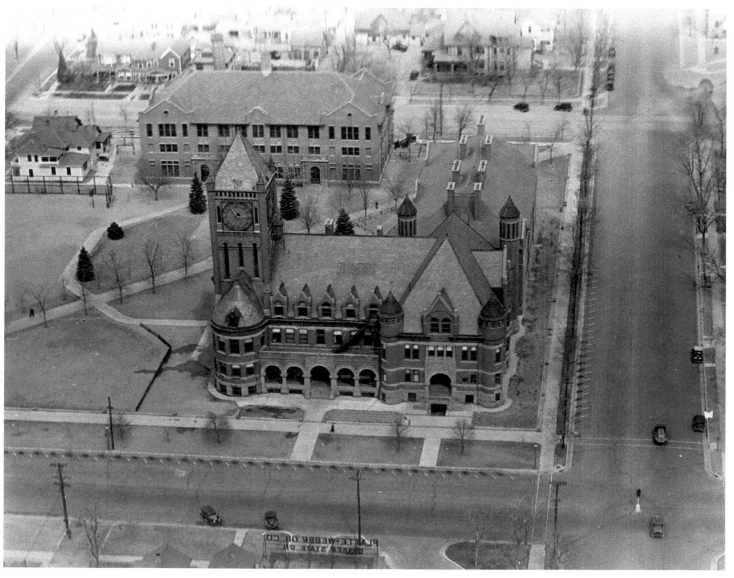

This aerial view from around 1930 shows the old Colorado Springs High School once located at Nevada and Platte avenues. The beautiful building opened in 1895 but was razed in 1938 to make space for a new school. Overcrowding forced School District 11 to build a second high school in 1959 (Wasson High School), and Colorado Springs High School changed its name to Palmer High School in honor of the General. Even today, the school's letters are "CS," in honor of the old name.

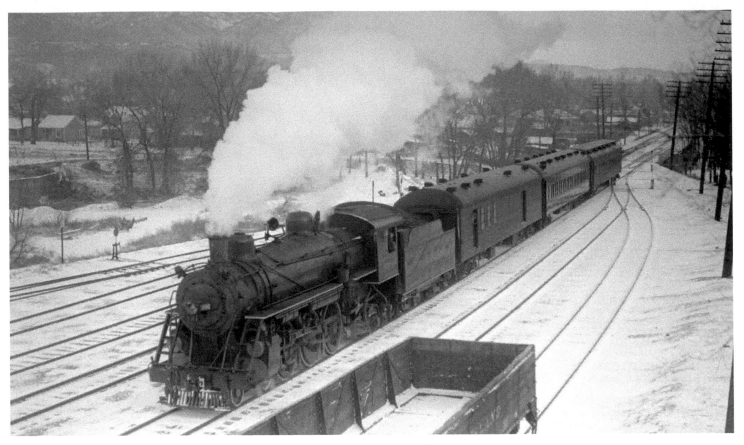

Chicago, Rock Island, and Pacific trains first rolled into Colorado Springs from the east in the 1880s. The tracks paralleled present-day Highway 24. The towns of Ramah, Calhan, and Peyton grew up along the route. This is engine no. 891 pulling the Rock Island's Colorado Express in 1931.

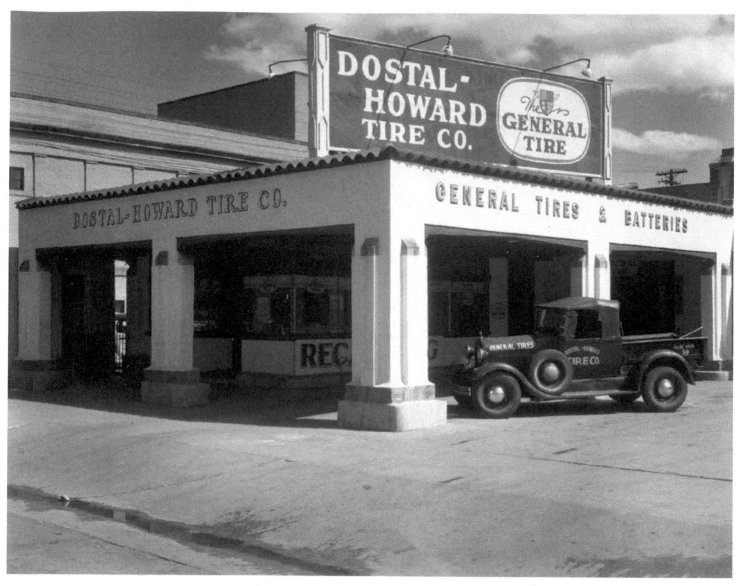

Shown here in the 1930s, the Dostal-Howard Tire Company did business at 211 East Kiowa Street. Typical of many businesses catering to motorists in the early years of the automobile, the Dostal-Howard building features distinctive architectural detailing— prominent here is its arcaded shelter with terra-cotta trim.

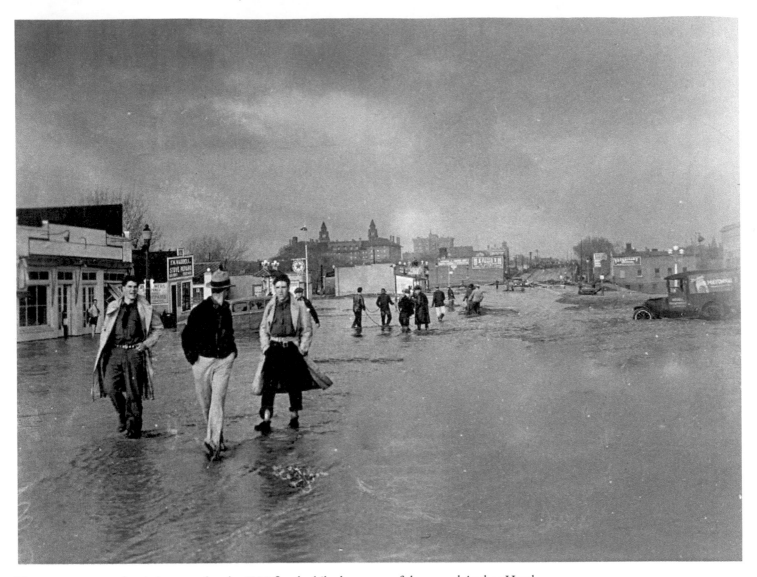

Young men traverse flooded streets after the 1935 flood while the towers of the second Antlers Hotel stand tall in the distance. One of the vehicles to the right is up to its axles in water on West Colorado Avenue as men with a rope attempt to reach out to marooned motorists. The Memorial Day flood washed away buildings and bridges and parts of Monument Valley Park, killing a number of people.

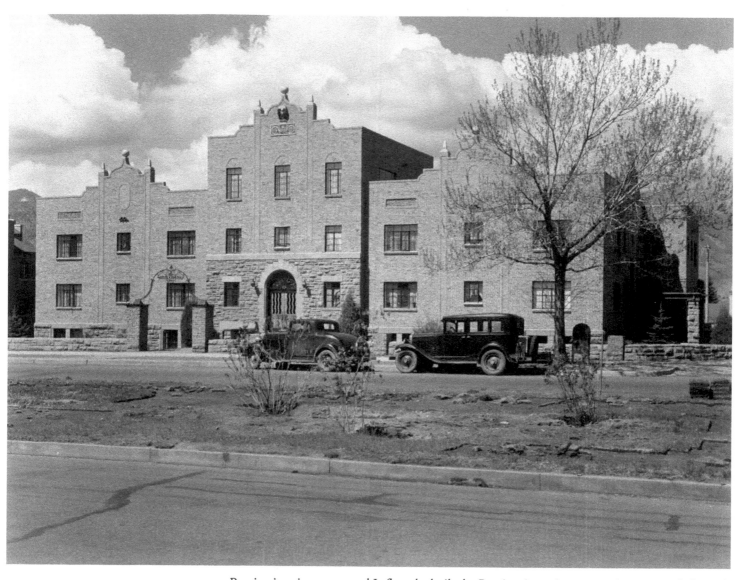

Russian immigrants named Lefkowsky built the Russian Arms Apartments in 1939 at 624 North Cascade Avenue. Originally planned as a home, the Lefkowskys configured the building into luxury apartments when money became short. It features decorative stone-and-brick arches and window openings, wrought-iron balconies, and tile ornaments. Today the building is called the Cascade Park Apartments and still operates as an apartment complex.

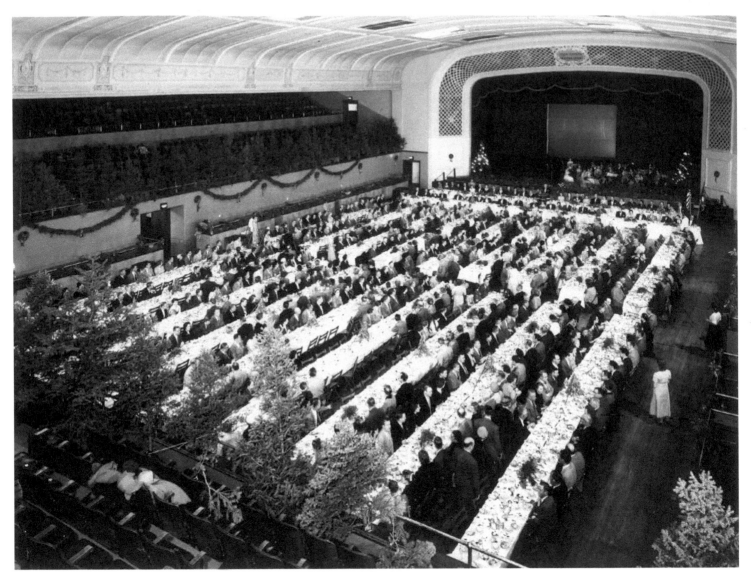

Built in 1923 as a concert venue, the Colorado Springs Civic Auditorium is shown here filled with people sitting at tables set for a lavish banquet. In recent years, the Pikes Peak Center and World Arena have hosted events that were once held here, while the historic Civic Auditorium has been used for graduations, flea markets, and small concerts. The auditorium includes a main floor and two balconies on three sides as well as a cafe and small theater.

The Modern Era

(1940–1970s)

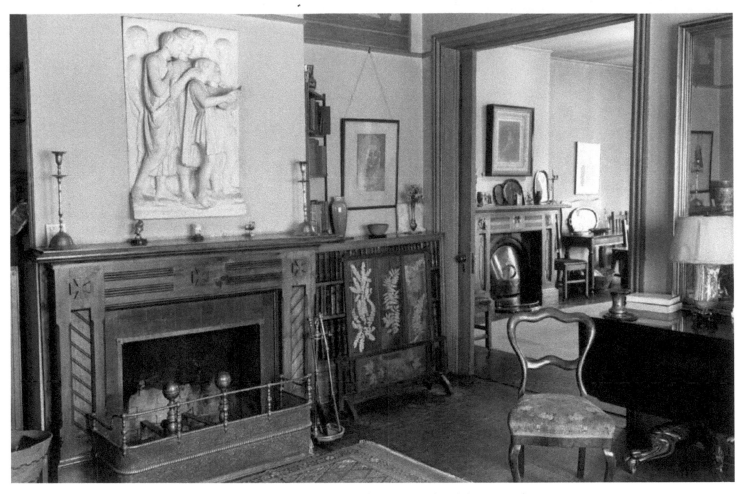

A wide doorway with pocket doors separates two sitting rooms in Helen Hunt Jackson's house. Both rooms have fireplaces with carved wooden mantels. A bas-relief sculpture is hanging on the wall above the fireplace at left. Several rooms from this lovely old home are on display at the Colorado Springs Pioneer Museum, saved before demolition of the structure.

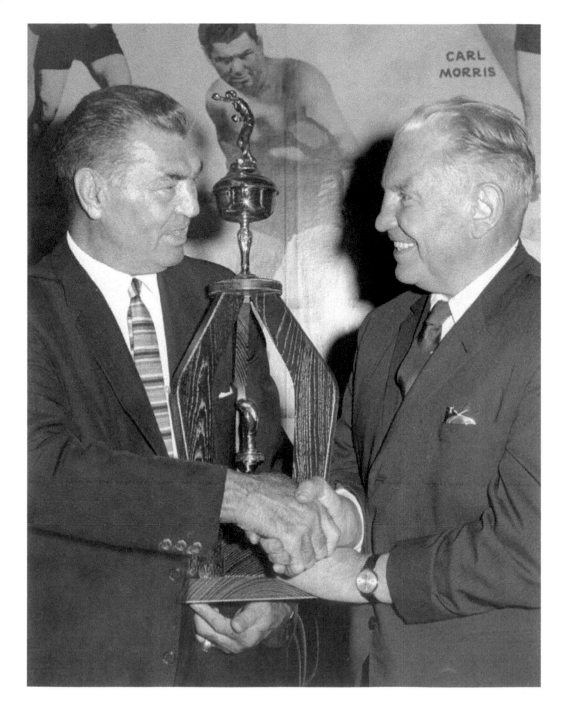

Boxer Jack Dempsey (at left) accepts the Foot Printer Award from Eddie Egan in Colorado Springs. Struggling to rise from an impoverished childhood, as a youth Dempsey worked the mines in Victor, Colorado, along with Lowell Thomas, the distinguished newspaperman. Discovering his talent for boxing, Dempsey went on to score 66 victories during a career of 84 professional fights. Spencer Penrose once invited him to train for several fights at the Turkey Creek ranch south of Colorado Springs.

Dr. Pepper Bottling Company employees in company khaki uniforms and ties hang a 1944 Dr. Pepper calendar on an office wall. The calendar features a woman in gardening togs and wide-brimmed hat relaxing against a wheelbarrow. Advertising art, especially from the 1940s and earlier decades, has long been a popular and widely collected bit of Americana.

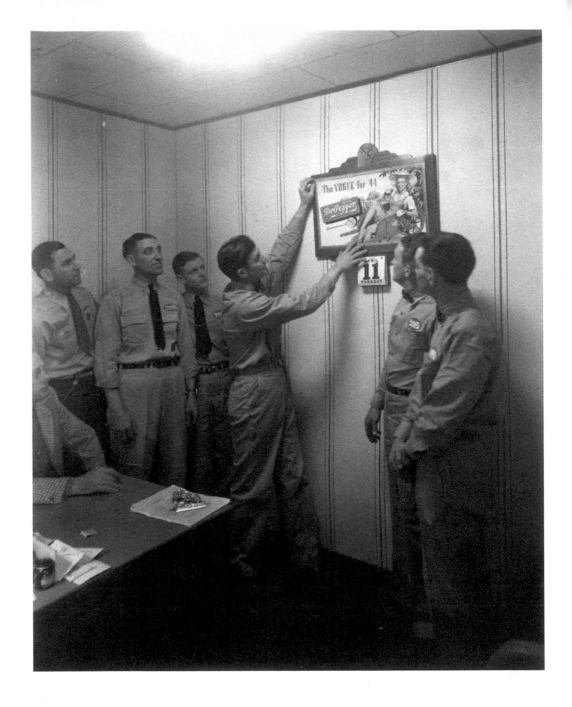

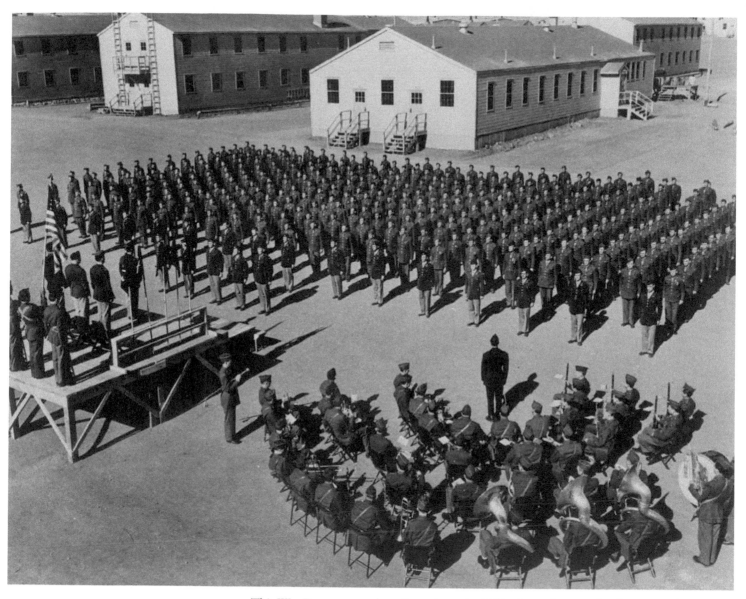

This War Department photo from the early 1940s shows the 122nd Infantry Greek Battalion receiving their company guidon at the conclusion of a ceremony at Camp Carson. The 353rd Infantry Regimental Band has assembled to play. The 122nd was an elite commando unit made up of American soldiers of Grecian ancestry who volunteered to fight on Greek soil during World War II. The casualty rate was extremely high.

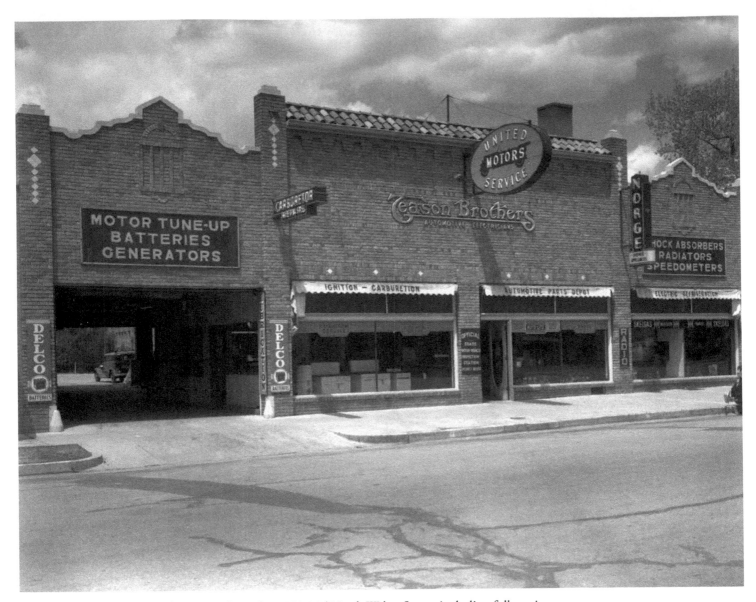

The Teason Brothers served the motorist's needs at 120-124 North Weber Street, including full-service automotive repair and a filling station, as well as a home appliance store. The brick storefront featured stone trim, pedimented flat roof, and a terra-cotta stepped cornice. Neon and hand-lettered signs advertised their services.

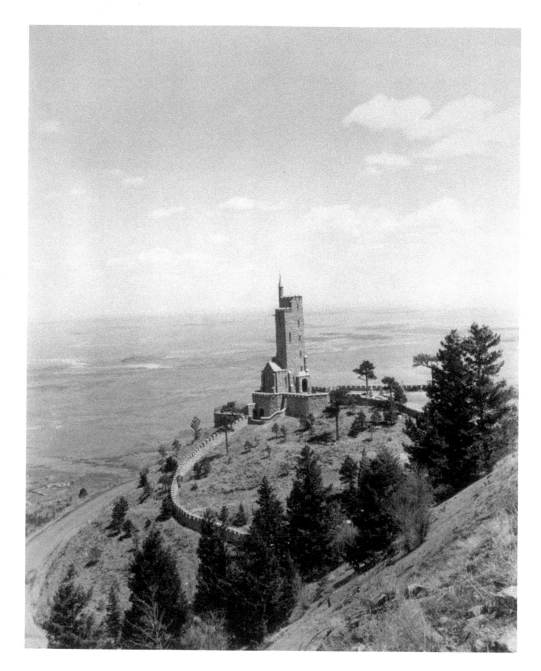

Commissioned by Spencer Penrose and dedicated to his friend Will Rogers, the "cowboy philosopher" who died in a plane crash in Alaska in 1935, the Will Rogers Shrine is located above the Cheyenne Mountain Zoo near the Broadmoor Hotel. Featuring Westminster chimes, a vibraharp, crenellated walls, and a turret, its 80-foot tower is constructed from a single boulder of local pink granite. Spencer and Julie Penrose are interred beneath the chapel floor.

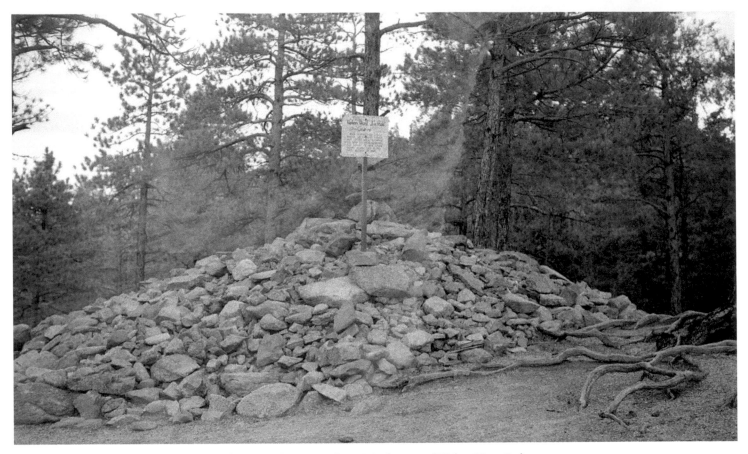

This large cairn of rocks on a hillside in Cheyenne Canyon is the original grave of Helen Hunt Jackson (1831–1885), author and Indian activist. The grave was moved to Evergreen Cemetery because pilgrimages made by increasing numbers of visitors were despoiling the wilderness area.

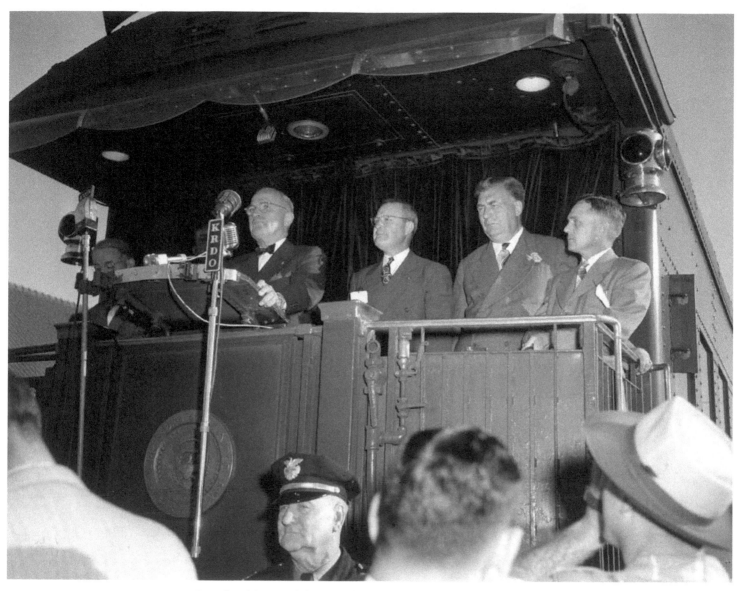

President Truman delivers a whistle-stop campaign speech in 1948 from the observation platform of his presidential railroad car. The two microphones at front are for "KVOR" and "KRDO," two local radio stations. On the platform with Truman are Governor Knous, Louis Poe, Senator E. C. Johnson, and John Marsalis of Pueblo.

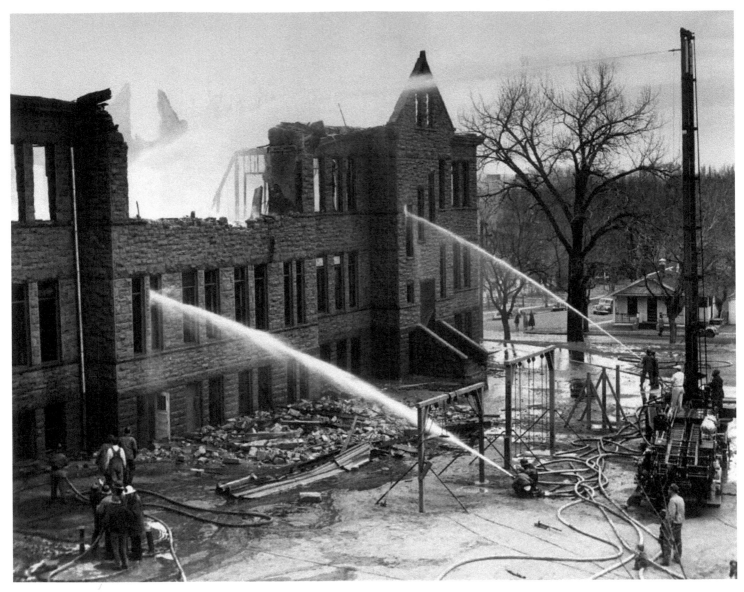

Firemen aim jets of water at the smoldering shell of the Colorado Institute for the Deaf and Blind in 1950. The school was rebuilt and today continues as a school for the deaf and the blind.

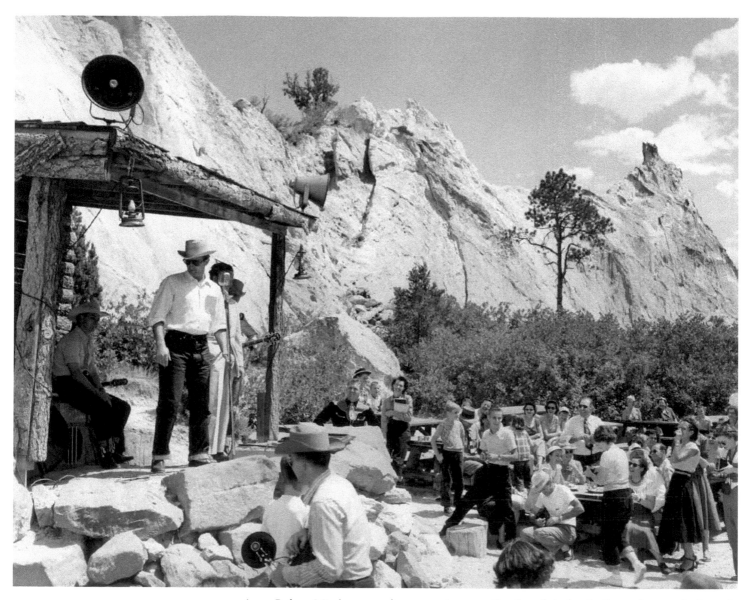

Actor Robert Mitchum stands on a rustic stage of rock and timber in front of a crowd of people sharing a meal at the Jaycee Chuck Wagon Dinner in the Garden of the Gods in 1952. Three men, including two with guitars, share the spotlight with him. Mitchum was in Colorado Springs for the premiere of his movie *One Minute to Zero*.

Located at 126 E. Pikes Peak Avenue across the street from the Peak Theatre, the Ute Theatre was built in 1935. *Against All Flags* starring Errol Flynn was playing here when this photo was taken in 1952. This night view focuses on the Ute's distinctive neon lighting. The Ute fell victim to urban renewal following a decline in ticket sales.

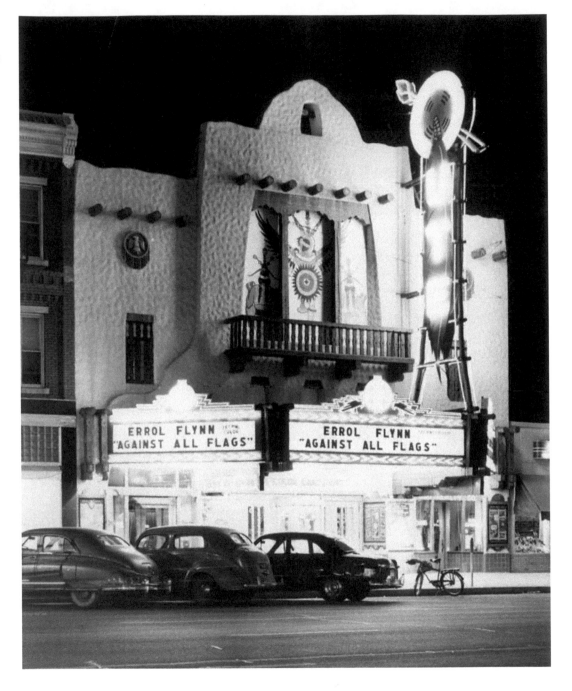

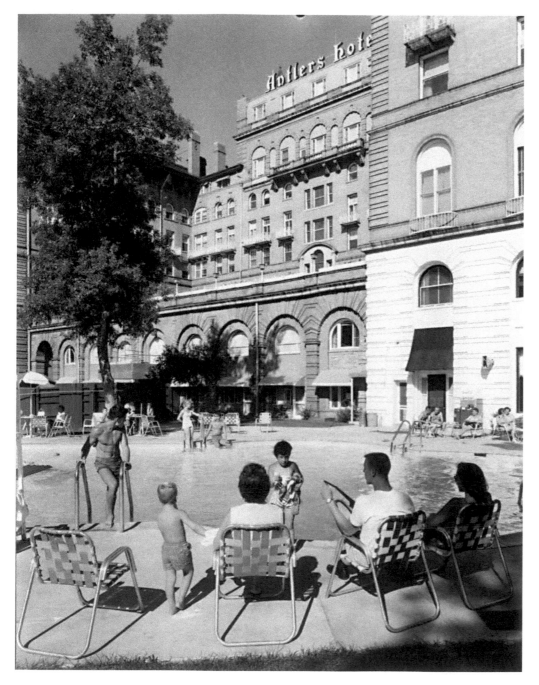

People lounge in outdoor chairs around the swimming pool at the second Antlers Hotel in the 1950s. This view shows the west side of the building.

Ski Broadmoor operated from the 1940s to the 1980s. Situated below Cheyenne Mountain, it offered only two to three slopes served by one chair lift and appealed mostly to beginners. The glass front building held a restaurant and ski shop. The recreational area closed when natural snowfall declined and financial difficulties rose. The lifts were removed but the bare runs are still visible from the city.

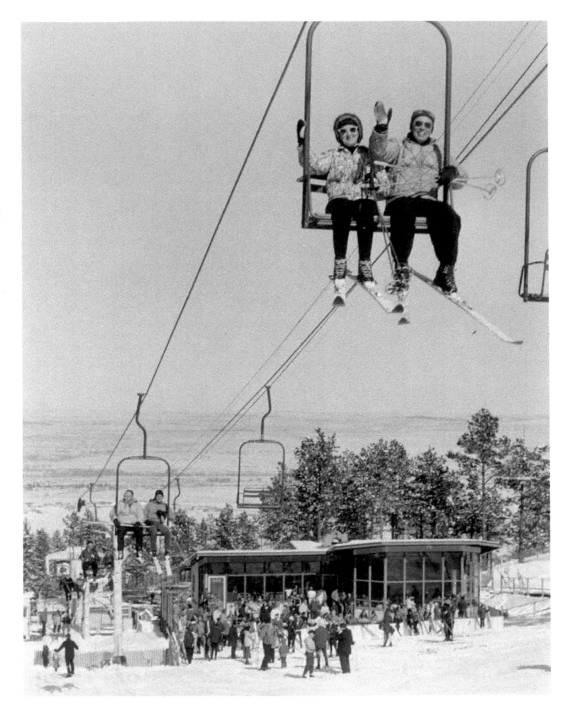

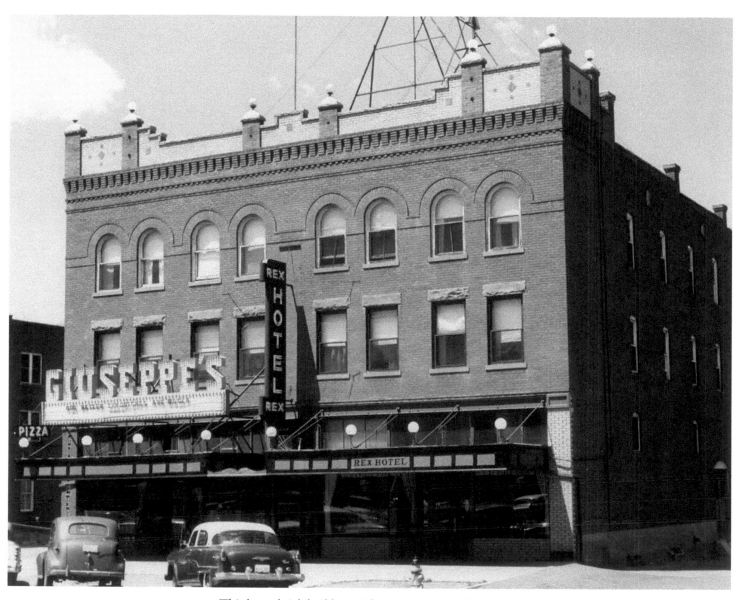

This large, brick building with a marquee over the entrance stands at 120 S. Cascade Avenue in the 1950s. It housed the Rex Hotel and Giuseppe's Restaurant, where "our better sandwiches are bigger." The Rex Hotel fell to urban renewal in the 1960s. Giuseppe's now occupies the old Denver and Rio Grande station west of the Antlers Hotel.

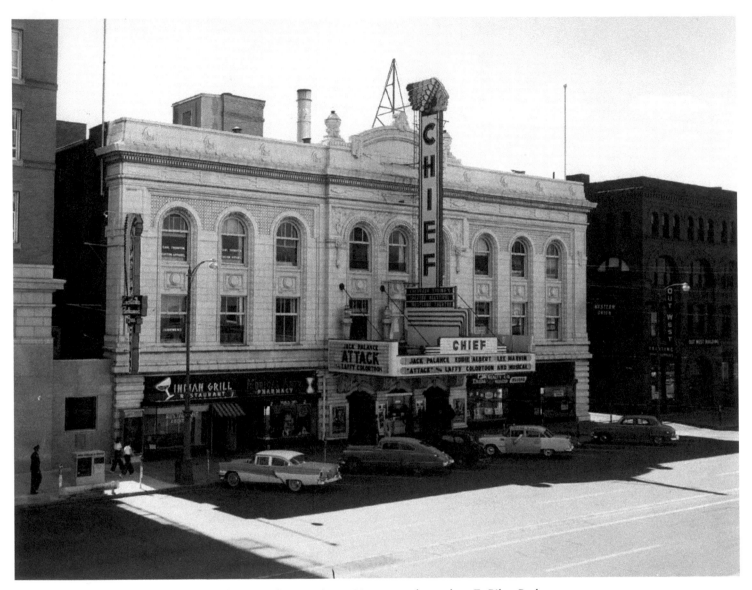

The Chief Theater, formerly the Burns Theatre and Burns Opera House, was located on E. Pikes Peak Avenue. *Attack*, with Jack Palance, Eddie Albert, and Lee Marvin, is playing at the theater here in the 1950s. Also in the Burns Building were the Indian Grill and the Medical Arts Pharmacy. The Burns would be razed in the 1970s.

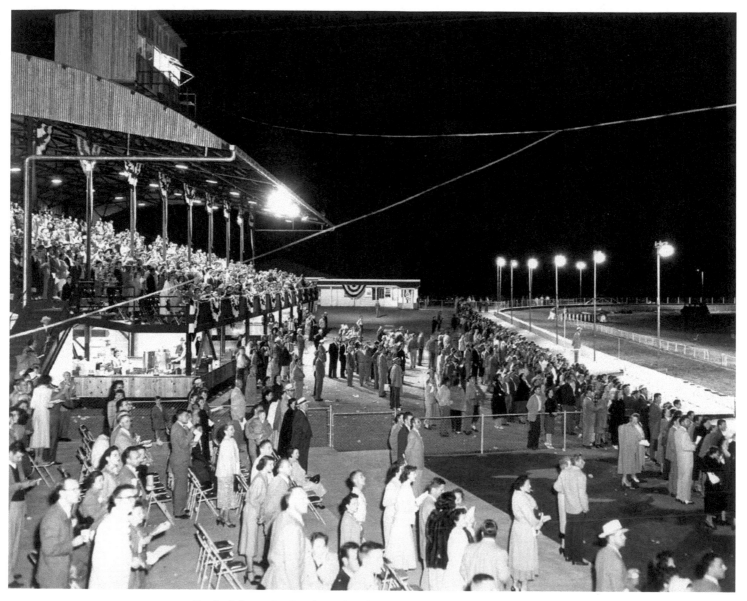

Rocky Mountain Greyhound Park was a busy evening attraction on North Nevada Avenue, offering live greyhound dog races. Crowds are watching a race from the railings and grandstand here in the 1950s.

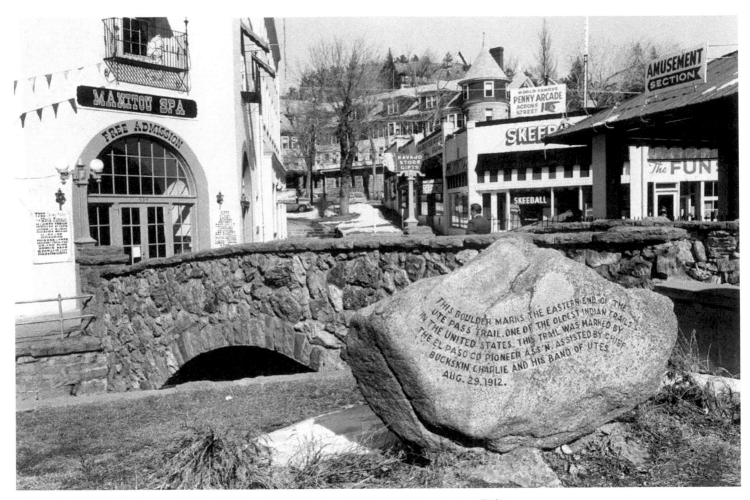

A large boulder beside the stone bridge in front of the Manitou Spa bears the inscription, "This boulder marks the eastern end of the Ute Pass Trail." The Pioneer Association placed the marker with the help of Chief Buckskin Charlie and fellow Utes during the Shan Kive celebration at the Garden of the Gods in 1912. Today, the "world famous" Penny Arcade, at top-right, still occupies the talents of pinball wizards, and at least one of its attractions is still only a penny a play.

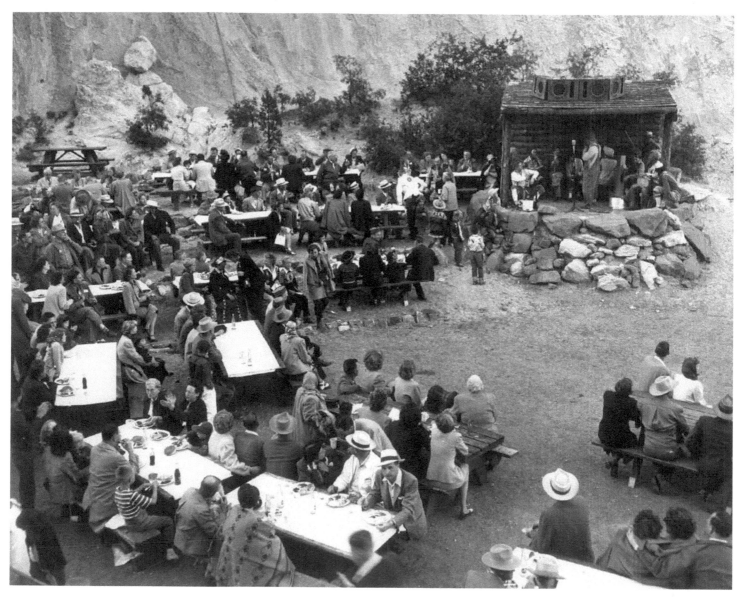

Guests enjoy dinner and entertainment at a picnic grounds in the Garden of the Gods during the 1950s. The Jaycees sponsored these tourist dinners. Today a large new parking lot occupies the same location.

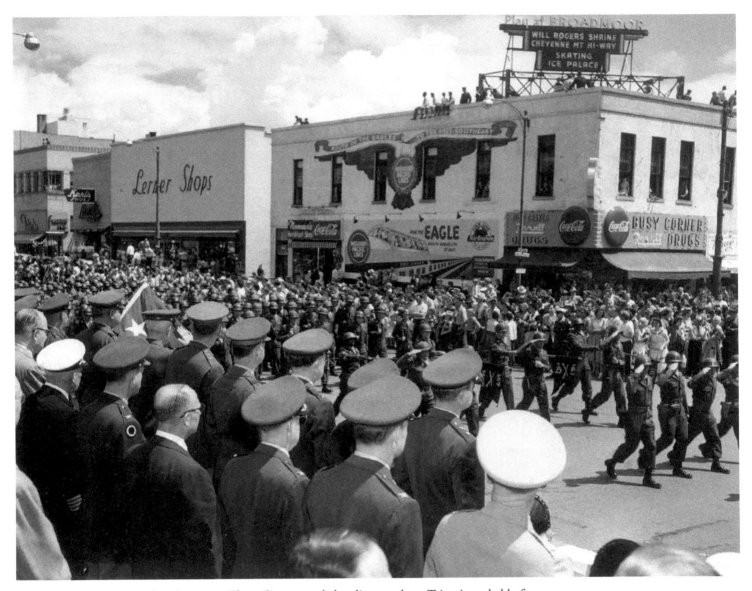

Busy Corner as it appeared in the 1950s. The military parade heading south on Tejon is probably from
Fort Carson. Businesses in view include Lerner's Clothing Store, at 7 North Tejon, and Busy Corner
Drugs, at 102 E. Pikes Peak.

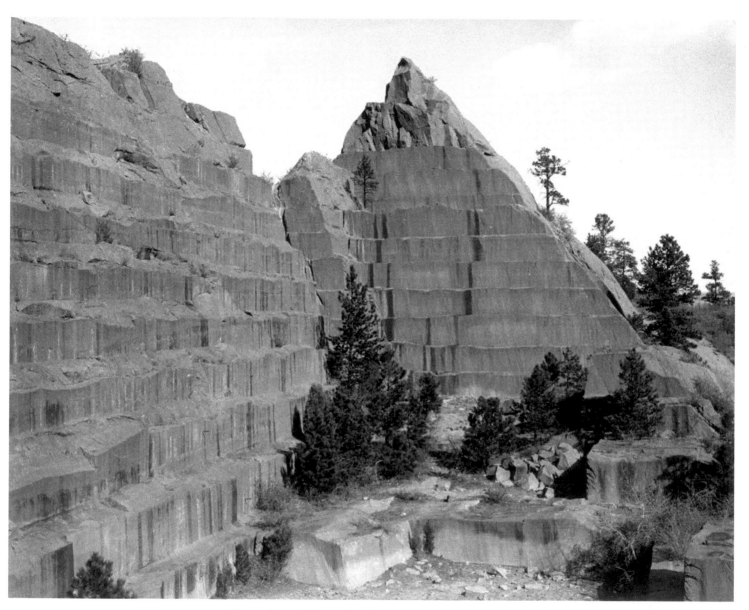

Shown here are the walls of a stone quarry south of Cimarron Avenue in Red Rocks Canyon. The stepped cuts are conspicuous. A spur of the Colorado Midland Railroad that ran to the canyon removed the sandstone blocks, many of which were used in the construction of buildings in Colorado Springs. Today hikers and sightseers use the Red Rocks Canyon open space for recreation.

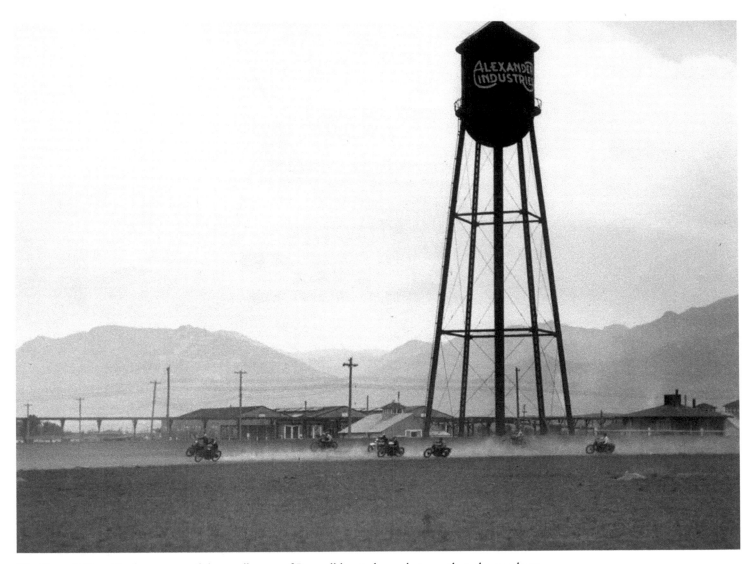

The Roswell Race Track was part of the small town of Roswell located on what was then the northern edge of Colorado Springs, off North Nevada Avenue. The town was a by-product of the arrival of the Chicago, Rock Island, and Pacific Railroad in the 1880s. The Alexander Industries water tower in the foreground served Alexander Film Company and Alexander Aircraft nearby. Roswell was annexed by the city in the 1950s.

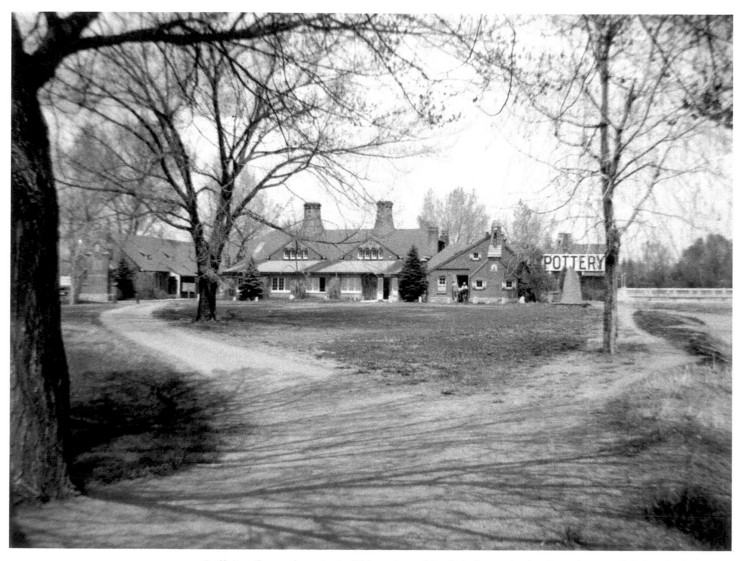

Suffering from tuberculosis, Ohioan Artus Van Briggle sought the drier climate of Colorado Springs in 1899, where he and wife-to-be Anne Gregory established the Van Briggle Pottery in 1901. His prize-winning art nouveau designs enjoyed world acclaim, but his career was cut short in 1904 when the gifted artisan succumbed to TB at the youthful age of 35. Van Briggle's widow went on to open the Van Briggle Memorial Pottery on Glen and Uintah, at the edge of Monument Valley Park, designed by Nicholas Van den Arend and built on land donated by General Palmer. The ornate structure opened in 1908.

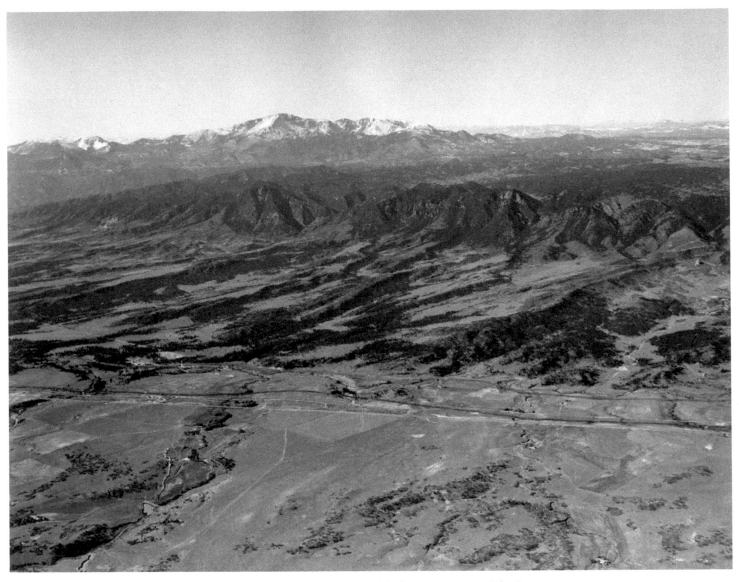

An aerial view of the United States Air Force Academy site around 1954 before construction. The Denver and Rio Grande and Santa Fe Railroad lines are both visible. Some 17,500 acres of land that lay nestled against the Rampart Range of the Rockies were acquired and construction began shortly afterward.

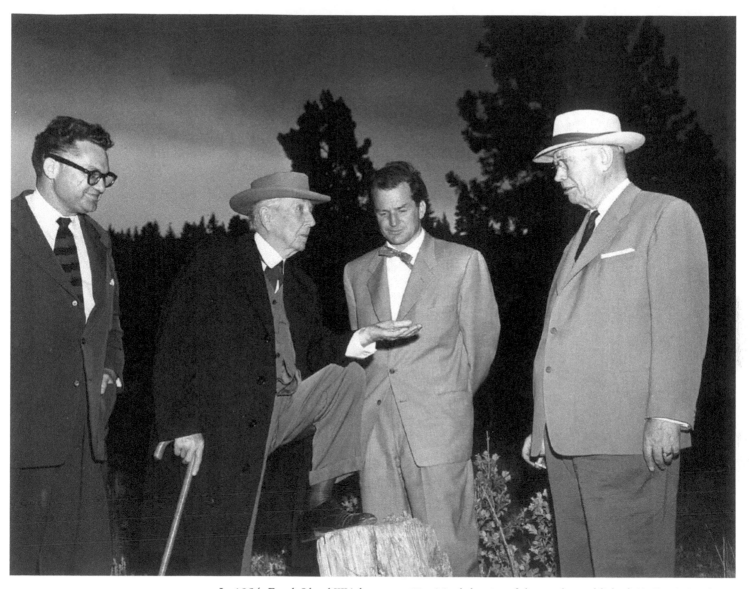

In 1954, Frank Lloyd Wright, at age 83, visited the site of the newly established Air Force Academy. Wright is shown with his foot on a stump talking to three businessmen. Originally, Wright was miffed at not having been selected as chief architect for the cadet chapel but later volunteered his advice.

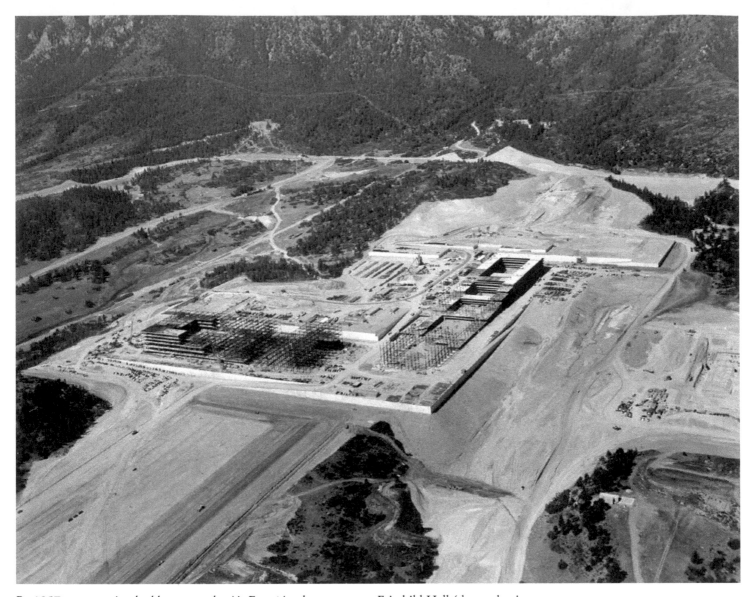

By 1957, construction had begun on the Air Force Academy campus. Fairchild Hall (the academic building) is visible at front with steel framework in place. Vandenberg Hall (the cadet dorm) is at right in various stages of construction. A weather station stands on a hill at lower-right.

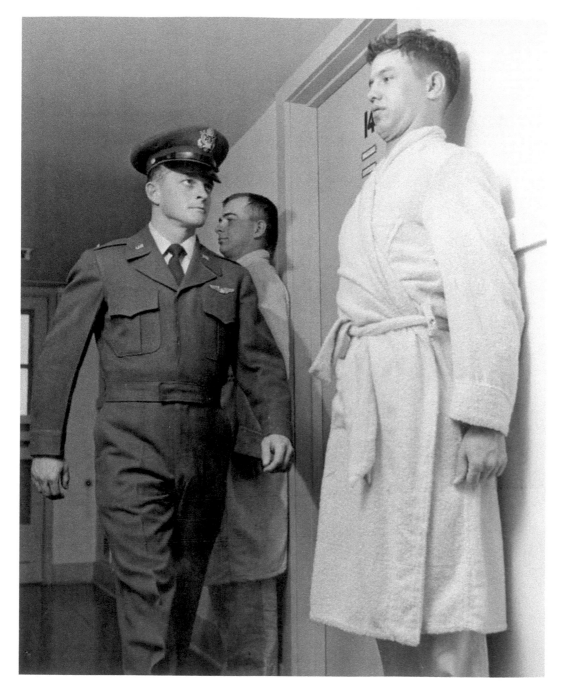

An Air Training Officer is inspecting a member of the Air Force Academy Class of 1959 in the cadet barracks at Lowry Air Force Base, before the move to the new facilities in Colorado Springs. The Class of 1959 was the first class to graduate from the academy. This cadet is standing outside his two-man room. A number of presidents, including Kennedy, Nixon, and Reagan, have spoken at Academy graduations.

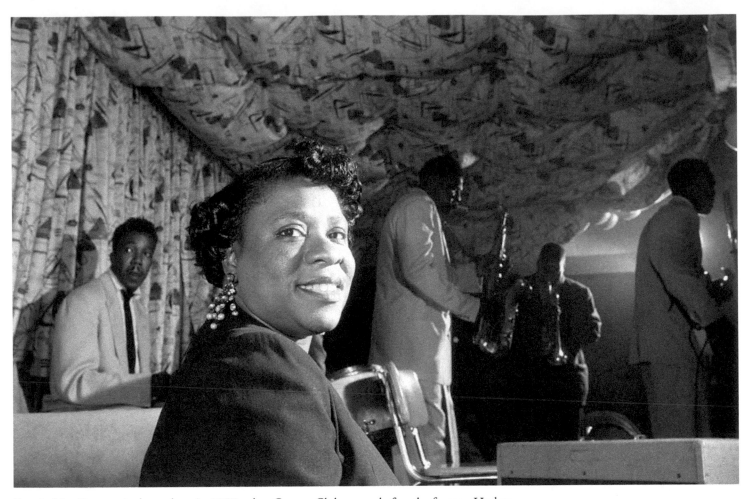

Fannie Mae Duncan is shown here in 1957 at her Cotton Club, named after the famous Harlem entertainment venue.

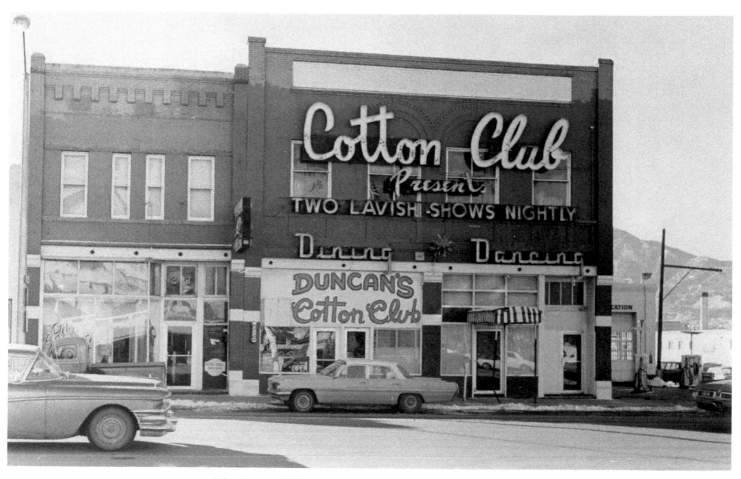

The Cotton Club was located on Colorado Avenue at Tejon Street. Owner Fannie Mae Duncan had expanded her family businesses from a barbershop and restaurant to include the live entertainment venue. Well-known black musicians entertained here, including Duke Ellington and Count Basie. Flip Wilson served as an emcee during the time he was stationed at Fort Carson with the Army. The Cotton Club was eventually torn down and replaced with the Sun Building.

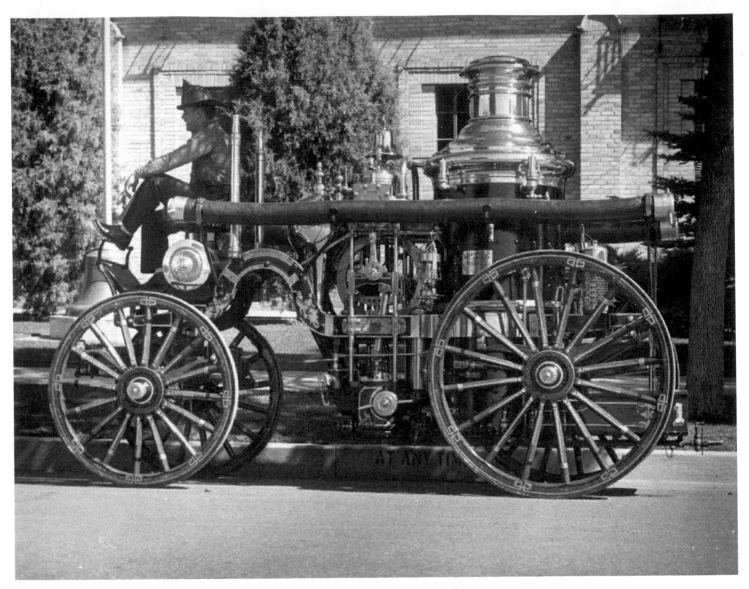

On a sunny August day in 1952 and at an unnamed event, this 1898 steam-pumper fire engine once again sees the streets of Colorado Springs. During its heyday, it would have charged to the scene of a fire behind a team of horses.

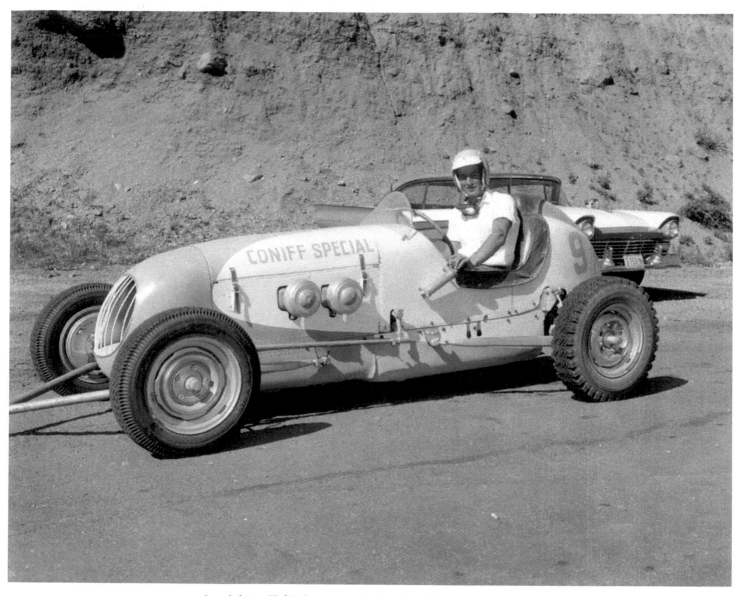

Local driver Ted Foltz is towed in his Coniff Special past a parked car along the Pikes Peak Hill Climb course in 1958. More than 50 cars were entered in the Open Wheel, Stock Car, and Sports Car classes that year. Total prize money was $21,655. Foltz finished 15th, completing the course in 15:50.5 minutes.

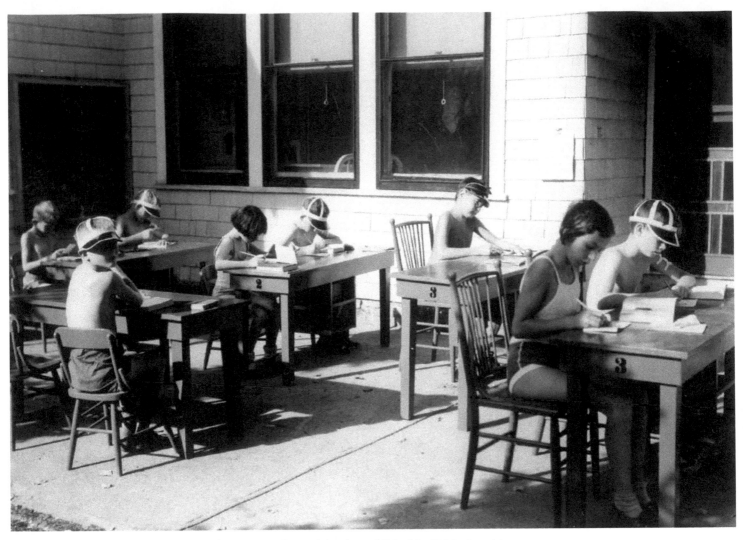

Students at the Junior League–sponsored Nutrition Camp School, established in 1924, sit writing at their desks. The original goal was to help malnourished children become healthier, to fight off the effects of tuberculosis. The League sponsored five beds the first year and by 1939 helped 450 children.

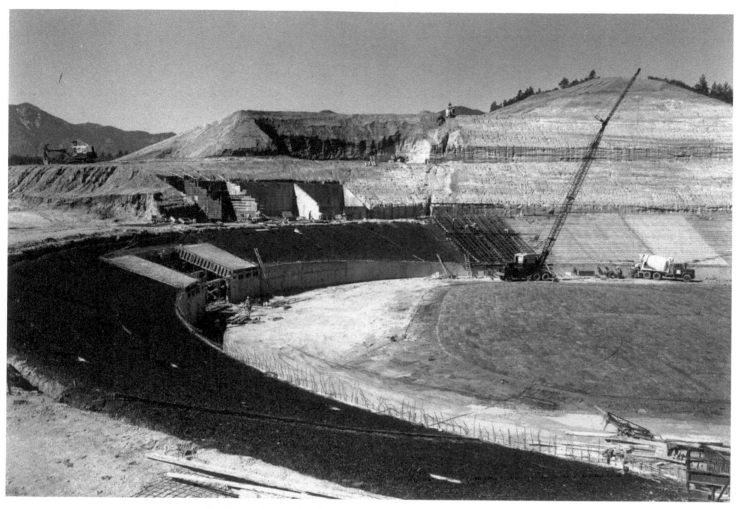

By September 1961, the Air Force Academy was constructing Falcon Stadium, today home to the Air Force Academy Fighting Falcon football team. The stadium's oval shape and tiered sides are clearly visible. In more recent times, another level has been added as well as skyboxes and night lighting.

A group of Fort Carson soldiers conduct field training with machine gun exercises.

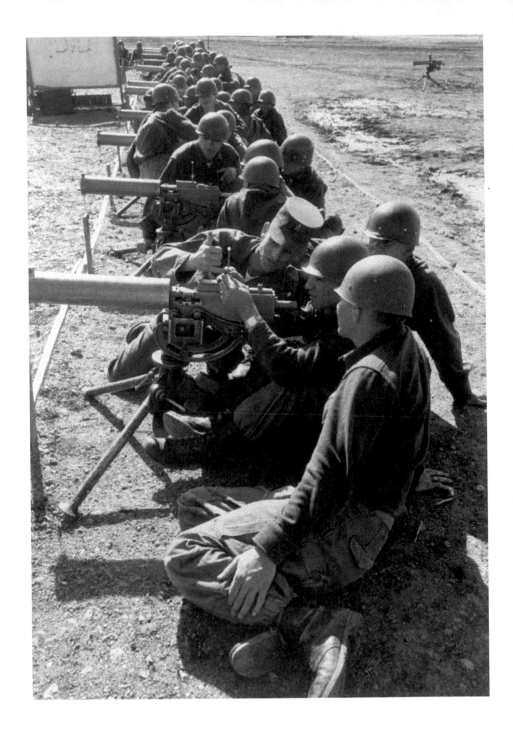

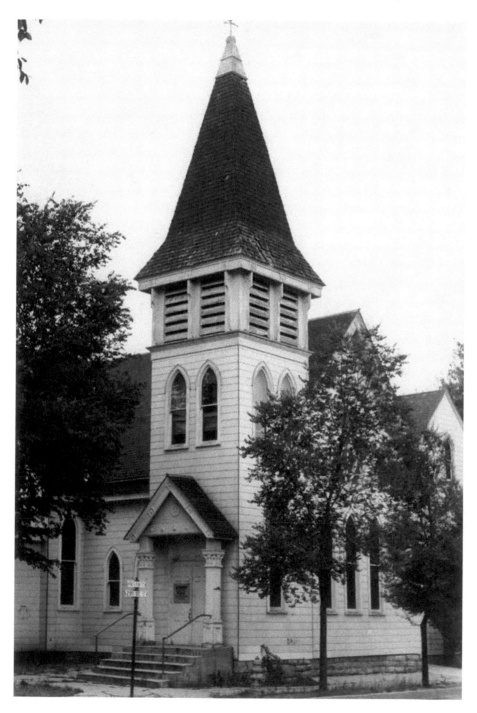

The First Methodist Episcopal Church stood at 2232 W. Pikes Peak Avenue, erected in 1901 at a cost of $11,000. The name was changed to Trinity Methodist Episcopal Church when Colorado City was annexed to Colorado Springs. The building was vacated in the early 1960s.

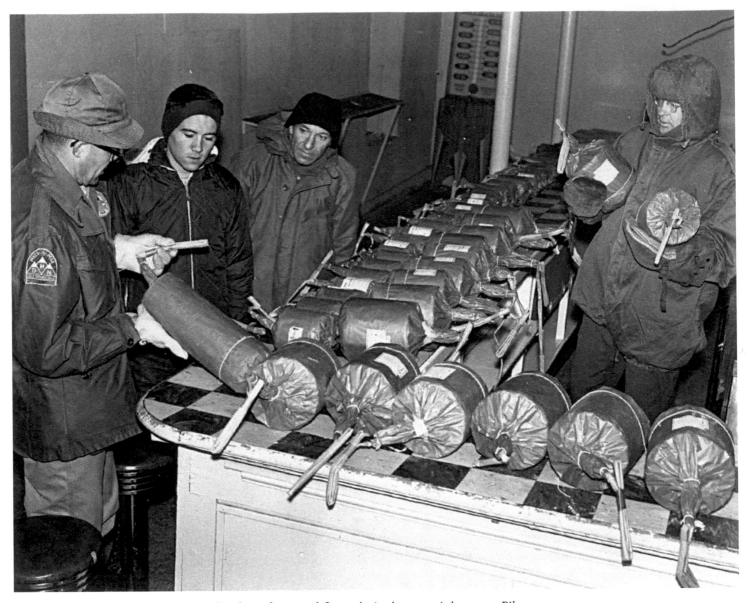

Four men from the AdAmAn Club study a line of wrapped fireworks in the summit house on Pikes Peak late in 1965, in preparation for the annual New Year's Eve display they provide for Colorado Springs residents.

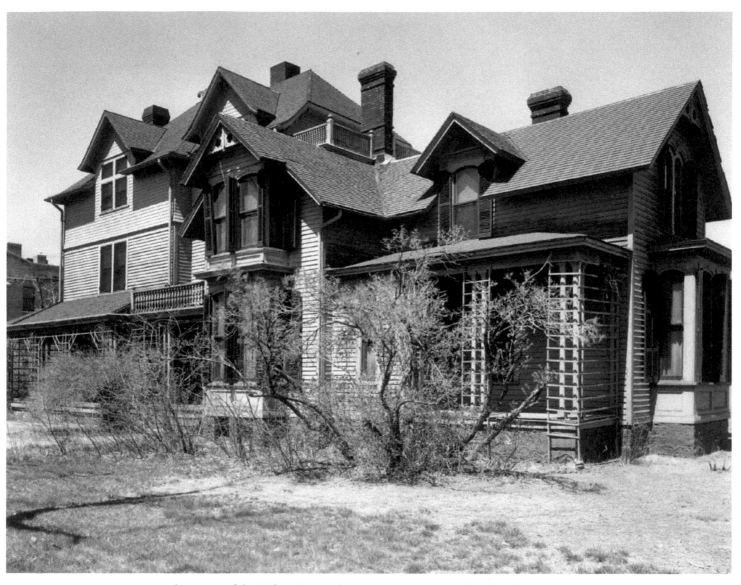

A close view of the Helen Hunt Jackson House at Kiowa and Weber before it was demolished. Jackson came to Colorado Springs for her health, meeting and marrying William Sharpless Jackson, a business partner of General Palmer's. The home was replaced with the new Colorado Springs Police Operations Center.

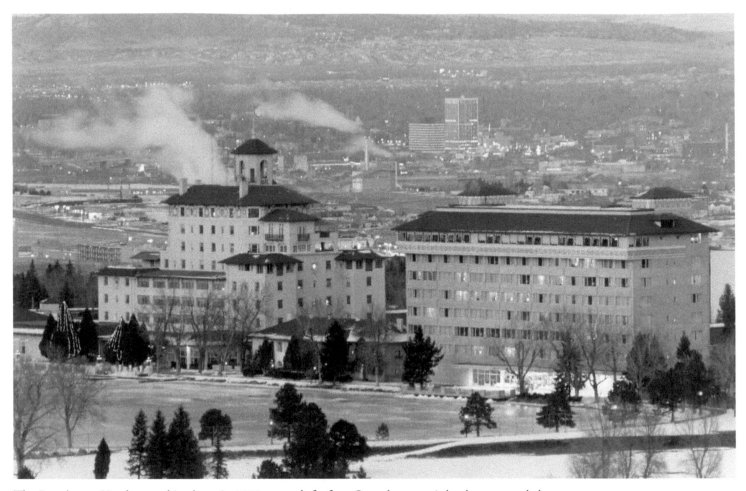

The Broadmoor Hotel opened its doors in 1918 to much fanfare. Over the years, it has been upgraded and expanded far beyond the facility envisioned even by its first owner Spencer Penrose. It has played host to numerous celebrities including presidents. This 1967 view shows the Broadmoor from the west with downtown visible behind.

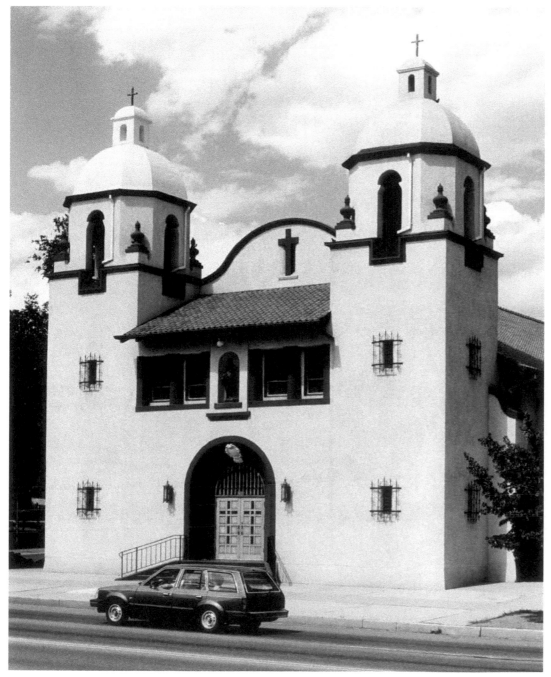

In the 1890s, Catholics in Colorado City had to travel to Manitou to attend mass until Anthony Bott, a Colorado City pioneer, donated lots for a Colorado City Catholic church. The original brick church and rectory were torn down and a new brick church was built in 1922. Popular architect Thomas MacLaren designed this Spanish mission–style facade with stucco veneer over the brick. Sacred Heart Church is still serving the community and is a Westside landmark.

More than two million visitors to Colorado Springs helped celebrate the nation's Bicentennial by touring the American Freedom Train when it stopped in the city October 3-5, 1975. People waited in line for hours for admittance. Exhibits inside the train covered all phases of America's 200-year history.

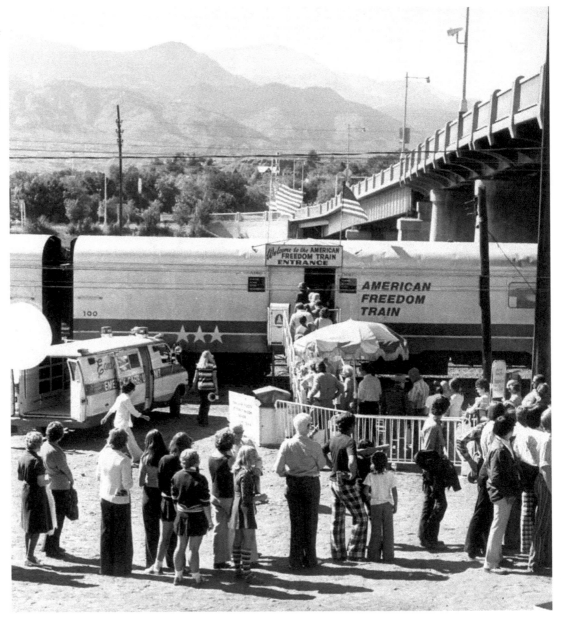

NOTES ON THE PHOTOGRAPHS

These notes, listed by page number, attempt to include all aspects known of the photographs. Each of the photographs is identified by the page number, a title or description, photographer and collection, archive, and call or box number when applicable. Although every attempt was made to collect all data, in some cases complete data may have been unavailable due to the age and condition of some of the photographs and records.